AUNTIES

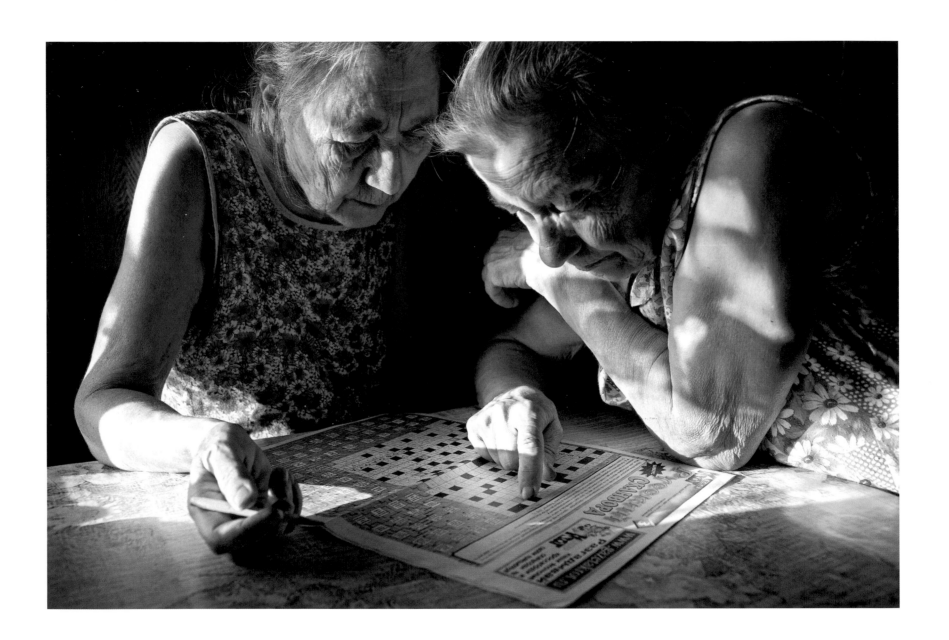

AUNTIES

The Seven Summers of Alevtina and Ludmila

❧

Photographs by Nadia Sablin

With a foreword by Sandra S. Phillips

Selected by Sandra S. Phillips to win the Center for Documentary Studies /
Honickman First Book Prize in Photography
A CDS Book published by Duke University Press
in association with the Center for Documentary Studies
Durham, North Carolina

To S., my dearest friend

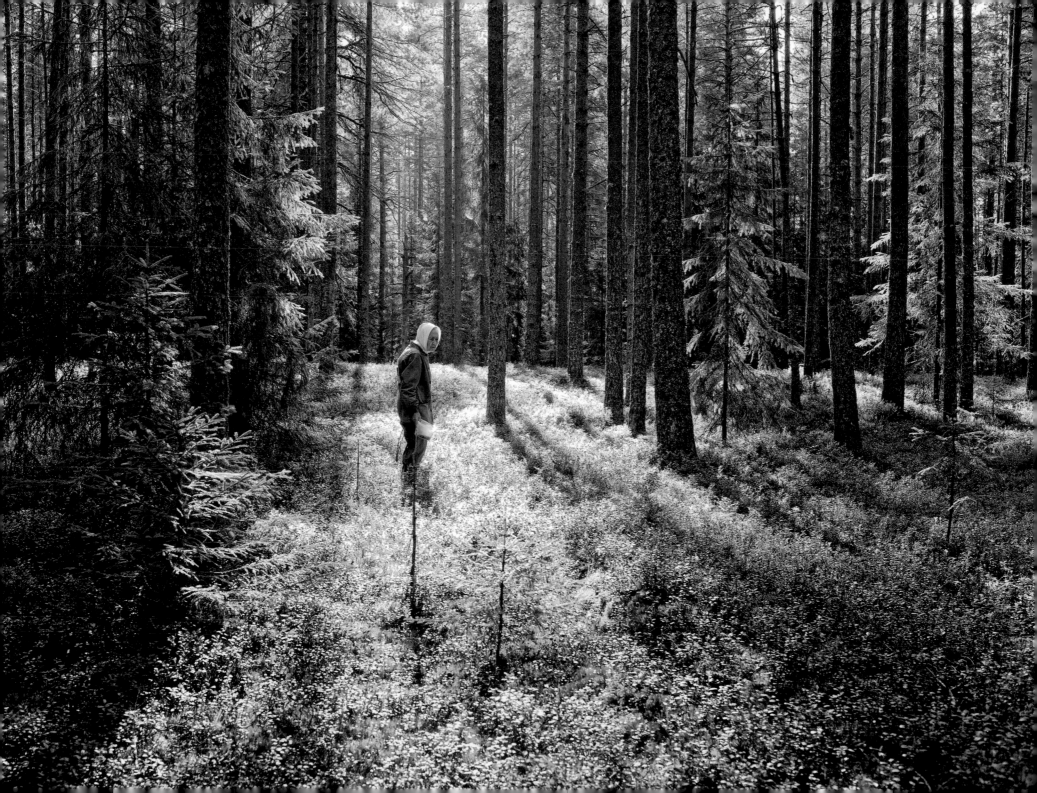

FOREWORD *Sandra S. Phillips*

You can almost feel the currents of air passing through these pictures as the light begins to fade, or smell the late summer strawberry jam as it is put into jars for the coming winter. In the evening the sisters will take down the long braids wrapped around their heads before they lie down to sleep. They will wake at dawn, work in the garden after the damp morning dew clears off, repair the fences that protect their cottage.

The sisters, Alevtina and Ludmila, work in simple colorful print dresses that are beyond fashion—so similar to the homemade dresses worn by frugal American farmers' wives of the last century. In the afternoons, they might take a break to embroider or watch a soap on their small television set. In the evenings, after a full day of work, they do crossword puzzles to amuse themselves. They go to the nearby town to buy provisions; they visit the sawmill to dig through piles of discarded lumber to repair the fences. They know the neighbors in town but keep their own company at home. They are each other's best friend. In fall, when the weather is intolerable and the snow too deep and frequent, they return to their apartments in the cities—Alevtina to Lodeynoye Pole and Ludmila to Veliky Novgorod—that provided them with jobs when they were younger. There they wait out the winter months and welcome the spring thaw and the light.

Nadia Sablin, who was born in Russia but has lived in the United States since she was a girl, has visited her father's sisters each summer for seven years now, finding comfort in knowing them and celebrating the lives they have chosen for themselves. It is a little tempting to not only admire these gentle, modest women but also to idealize their lives. Their bright clothing, the pleasing picturesqueness of their home and surroundings, bring to mind the bright-colored illustrations in Russian fairy-tale books that were so important to such modern artists as Wassily Kandinsky. In these pictures it is always spring or summer, the garden flourishes, the women enjoy the span of the seasons. The photographs are warm with an aroma of the magical.

Like so many representations of our own American farm families of the past, the sisters seem to exist in a privileged, even charmed, reality. This is not to minimize their effort, which is acknowledged. They are no longer young and their necessary chores demand effort. They cut the tall summer grass with a scythe; they make their own clothes just as their parents once did. They clearly have limited means, but we also sense that this is a life they have chosen and that they are happy. Their home is seen as a place of ancient custom; they know who they are and are content with what they do.

Lives like these used to be normal everywhere, but they are at a remove, even antique, now. Though the sisters live with deliberate modesty, their lives are shown as full of meaning and pleasure. Sablin also admits to directing her aunts a little, probably to emphasize the folkloric nature of what she sees. We know that this kind of life will feel even more remote and virtually impossible to pursue in the near future.

More people in the world now live in cities than in the countryside. While we, who live in cities, may mythologize the measured rituals of country living, the country is generally not where we choose to raise our families. Many of the customs of self-sufficiency in farming communities have already disappeared, and farming has now become, in our country and others, a specialized occupation where the goal is to make a profit, not to live fully and harmoniously. In the 1930s, Wright Morris made pictures of plain people's homes: farmers of the American Midwest who contended with drought, pests, searing winds in the winter, and crop failures in the growing season. His photographs represent their hard, admirable lives through the worn carpets he found in their homes, the battered scythe leaning against the barn door, the ancient furniture in their drafty rooms, the collections of old buttons in sewing drawers, saved to repair clothing. Morris's pictures take notice of what we have gained, but also of what we have lost. The photographs of Nadia Sablin are more engaged, warmer, more eagerly appreciative, but no less aware of the transience of these graceful women's lives, and of their culture. She chooses to show their way of living as almost enchanted: we can hardly believe that what we see in these pictures will ever disappear.

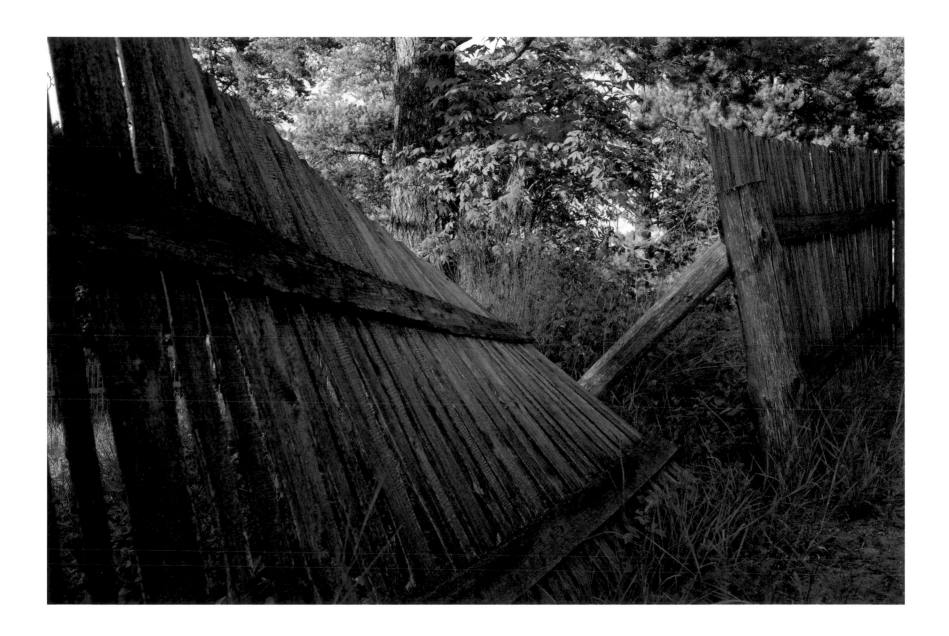

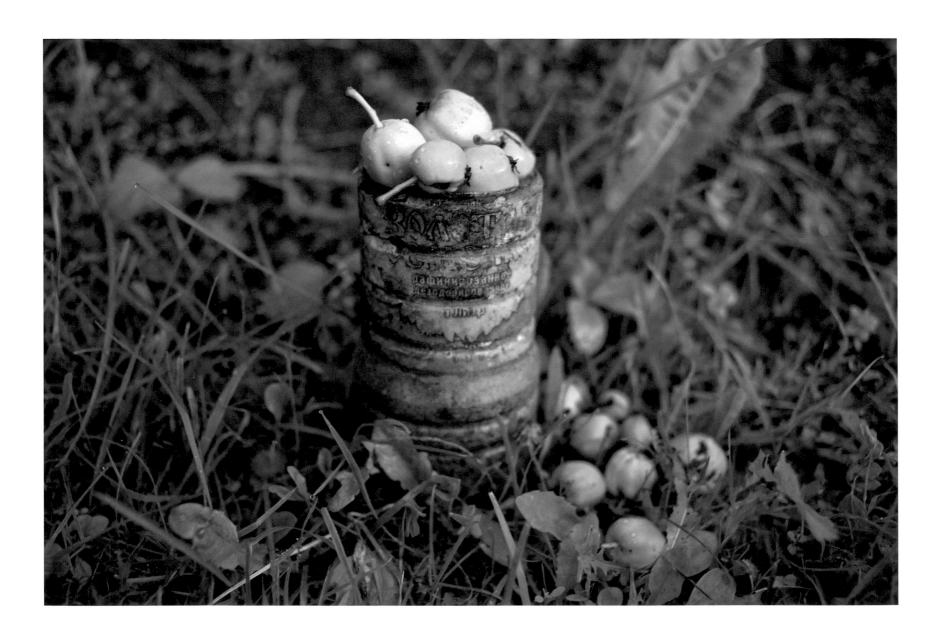

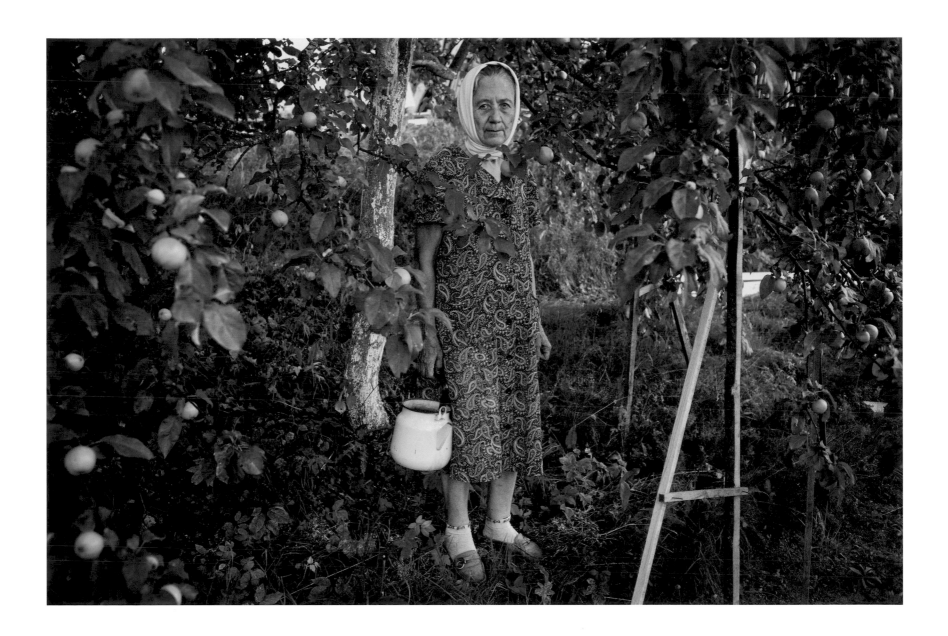

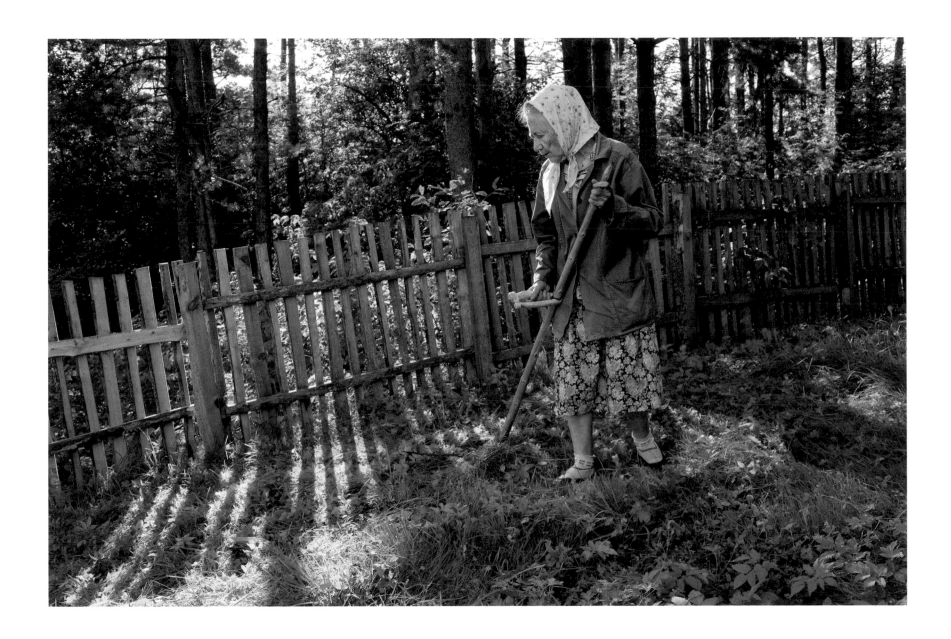

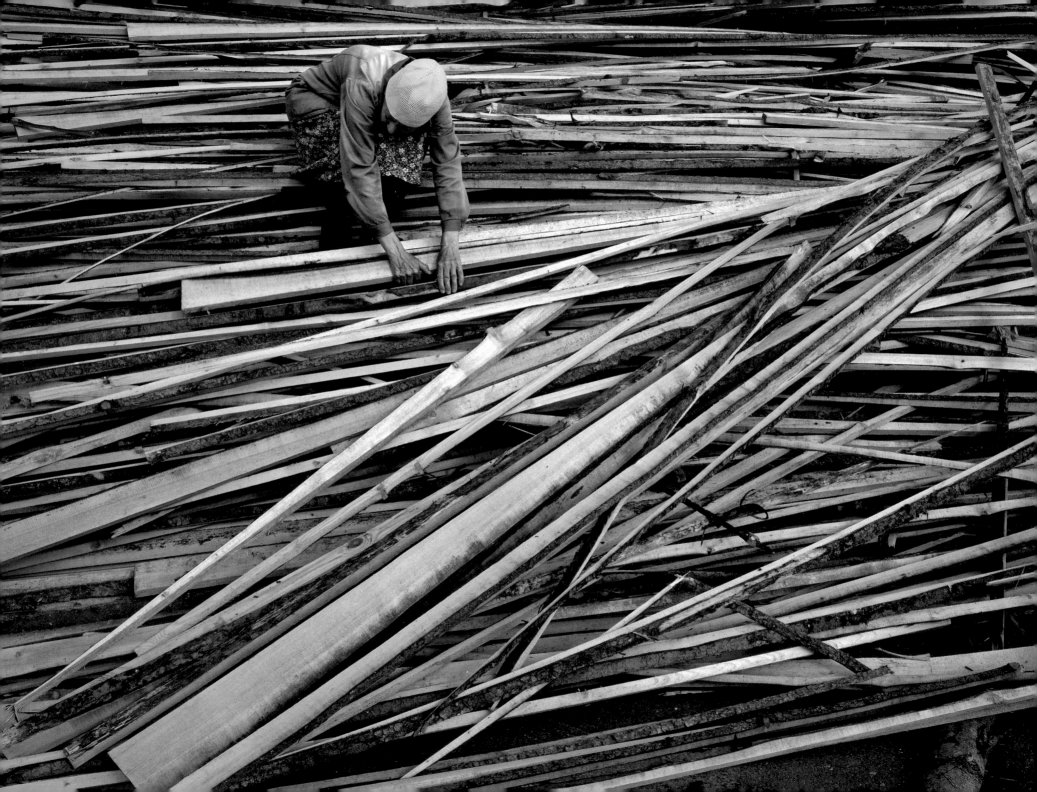

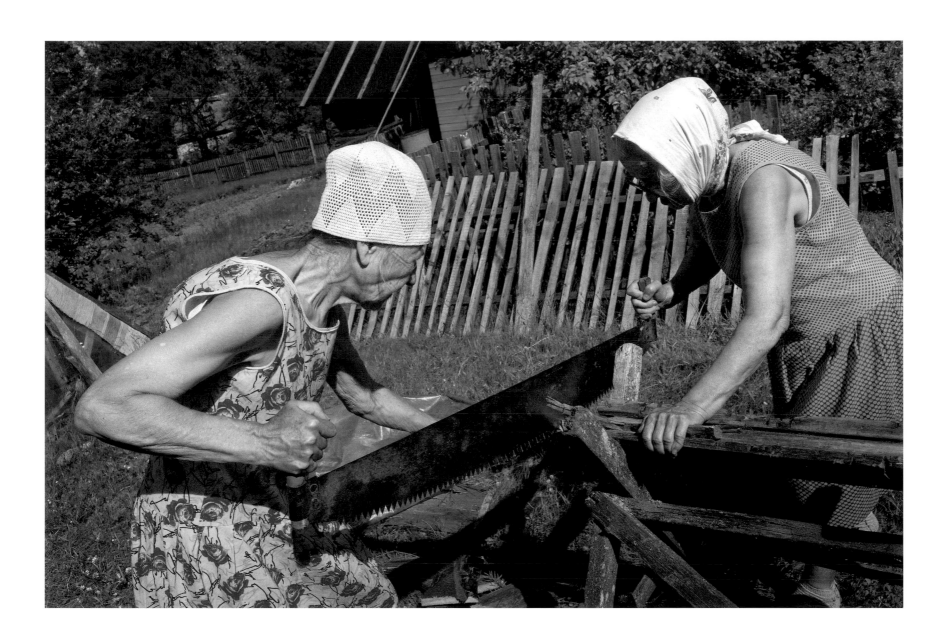

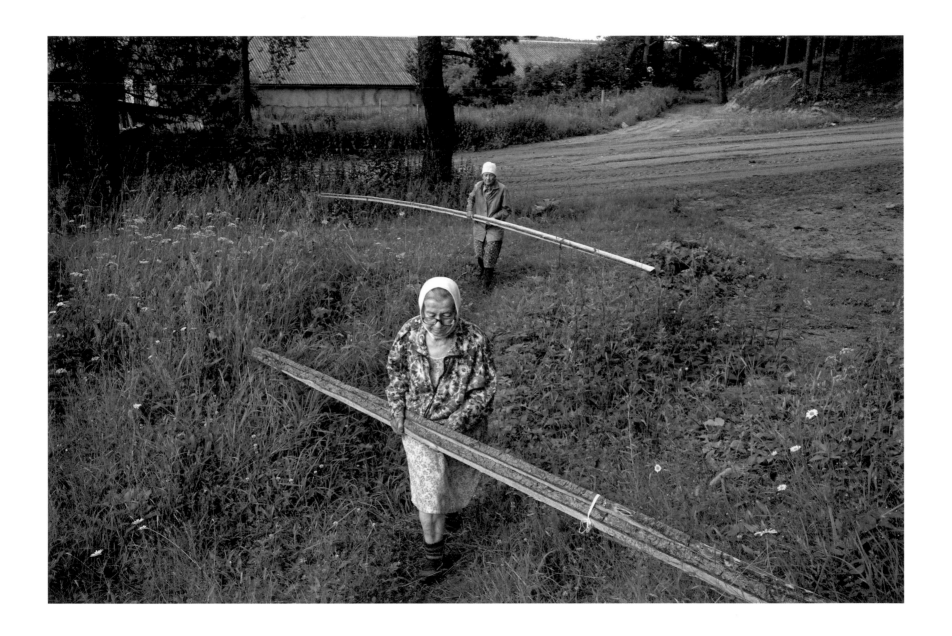

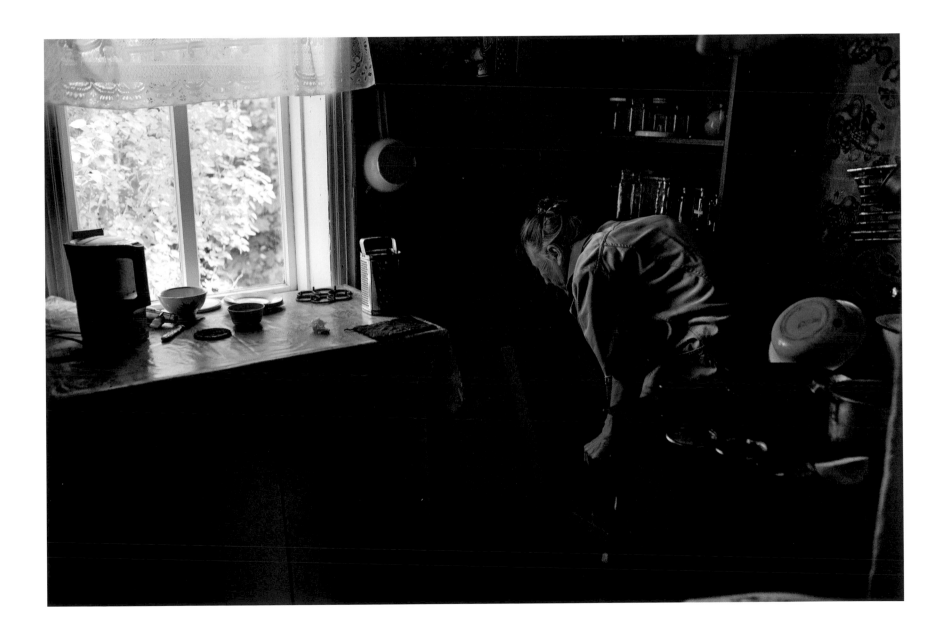

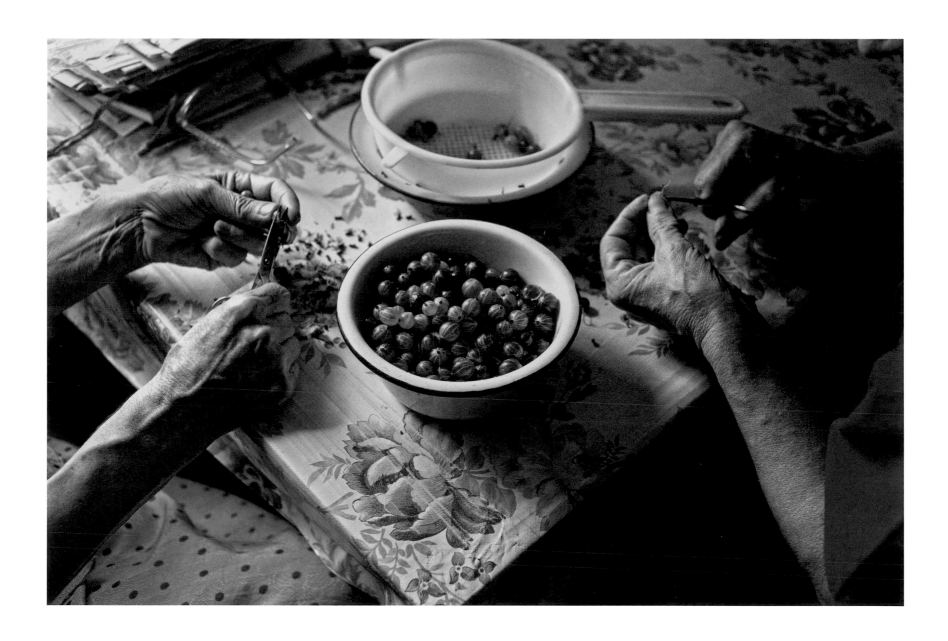

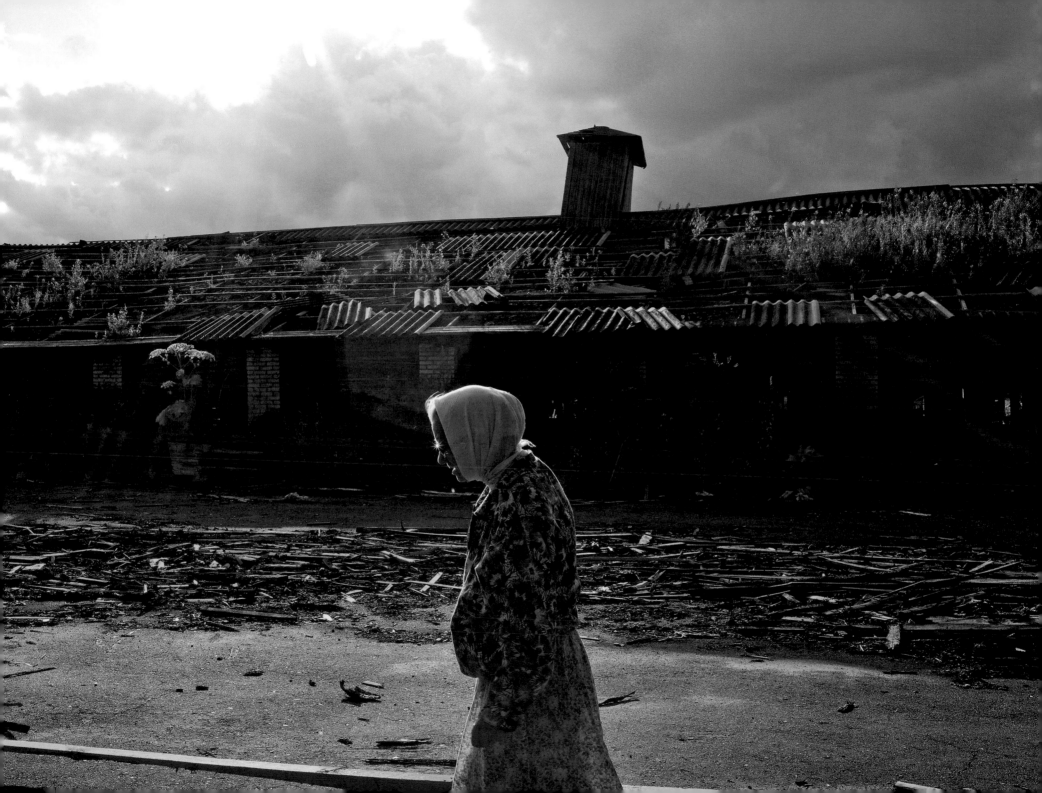

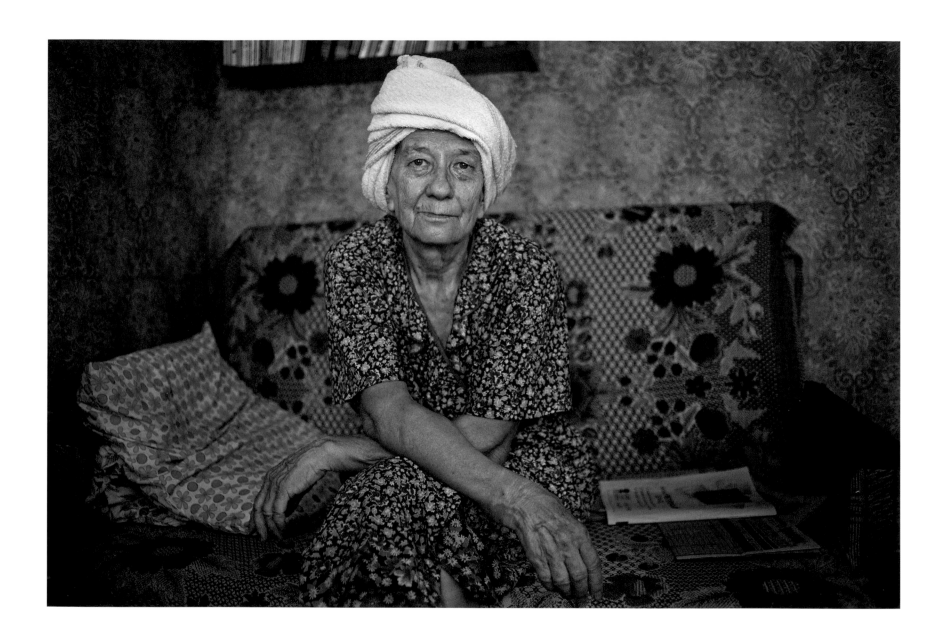

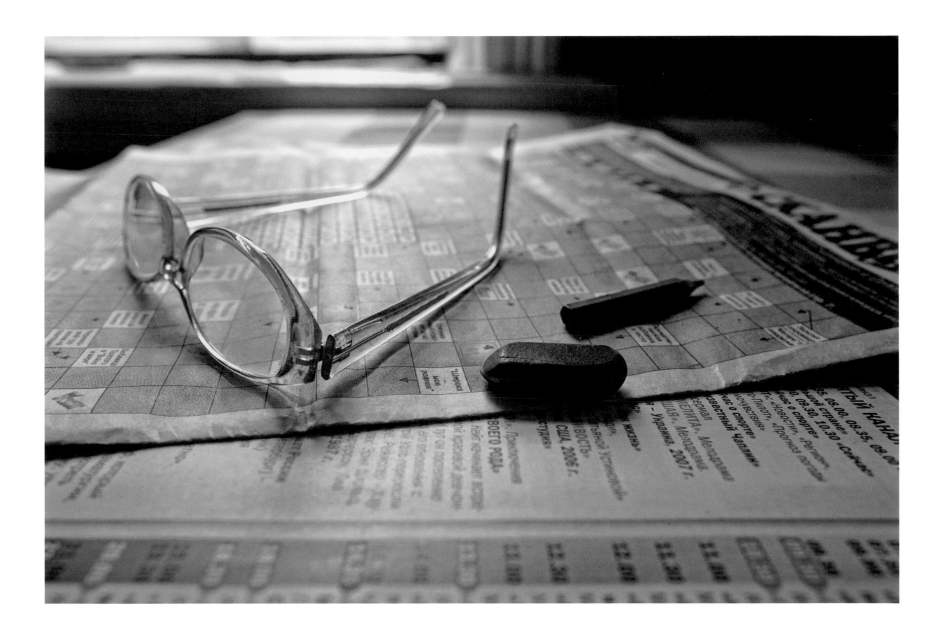

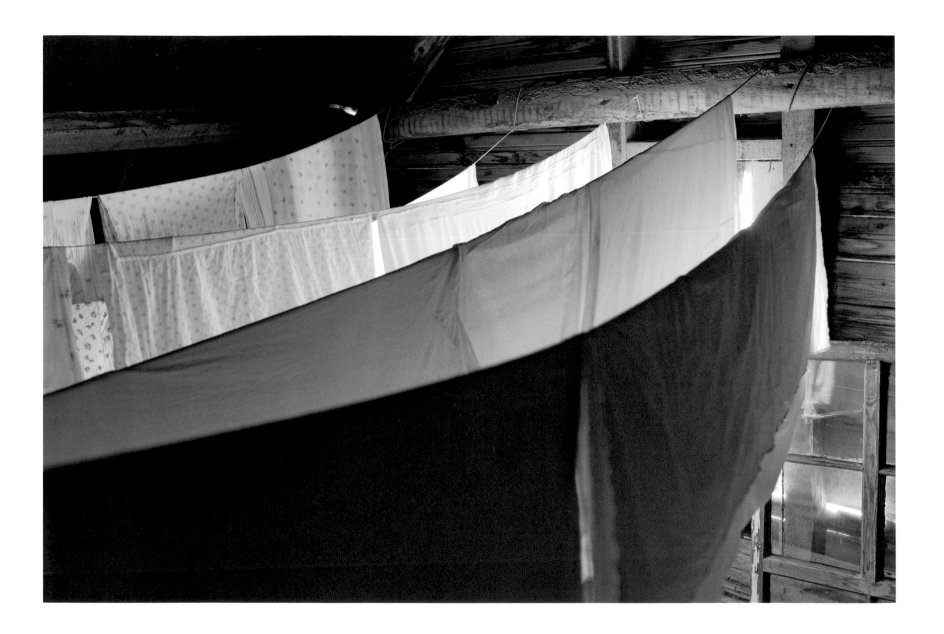

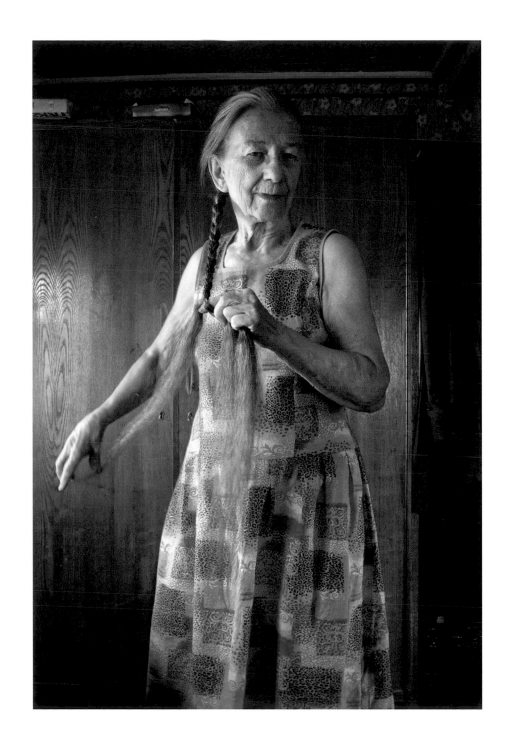

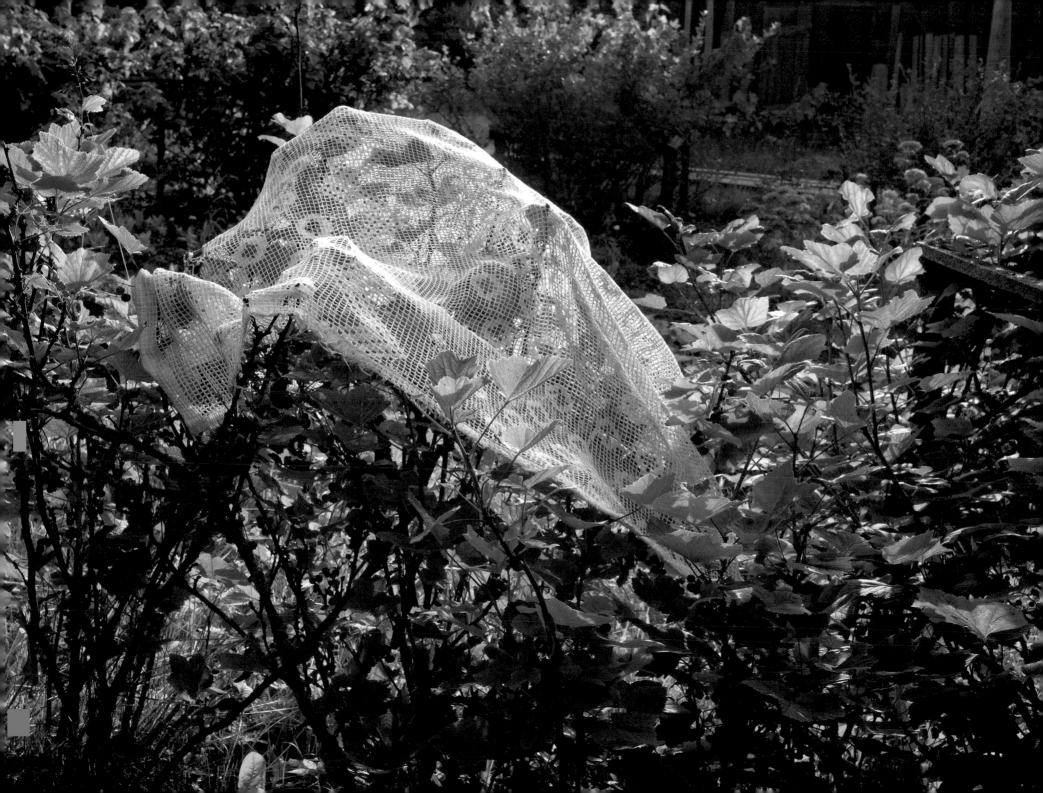

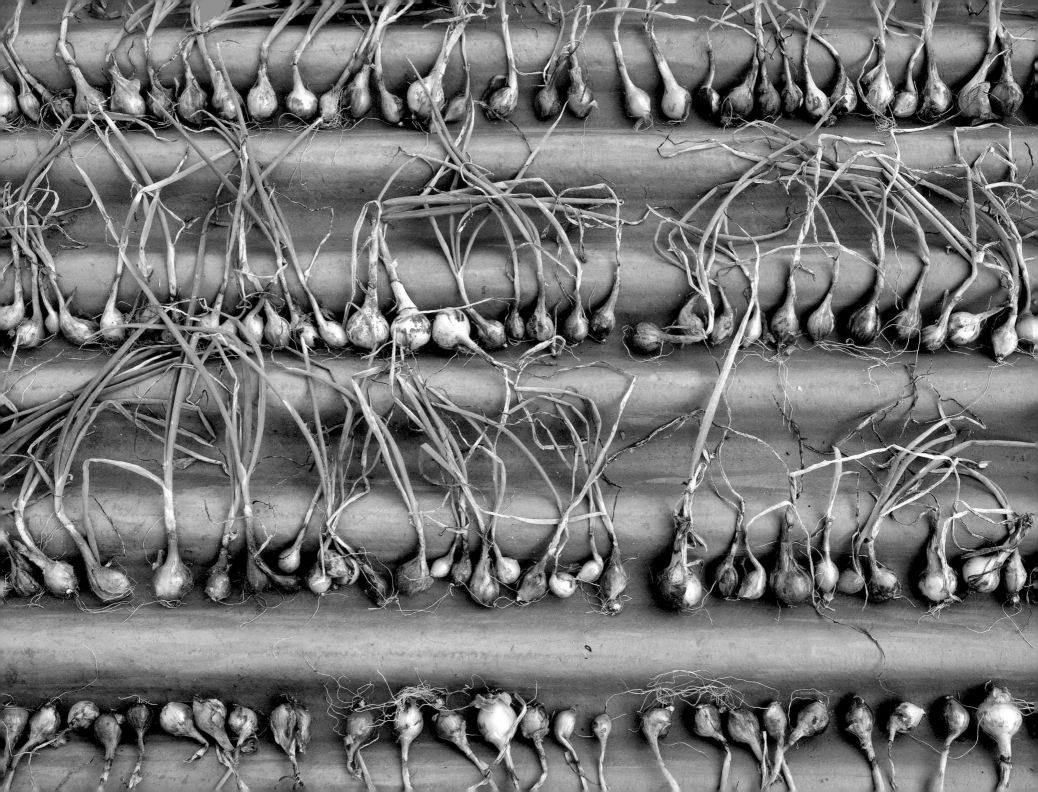

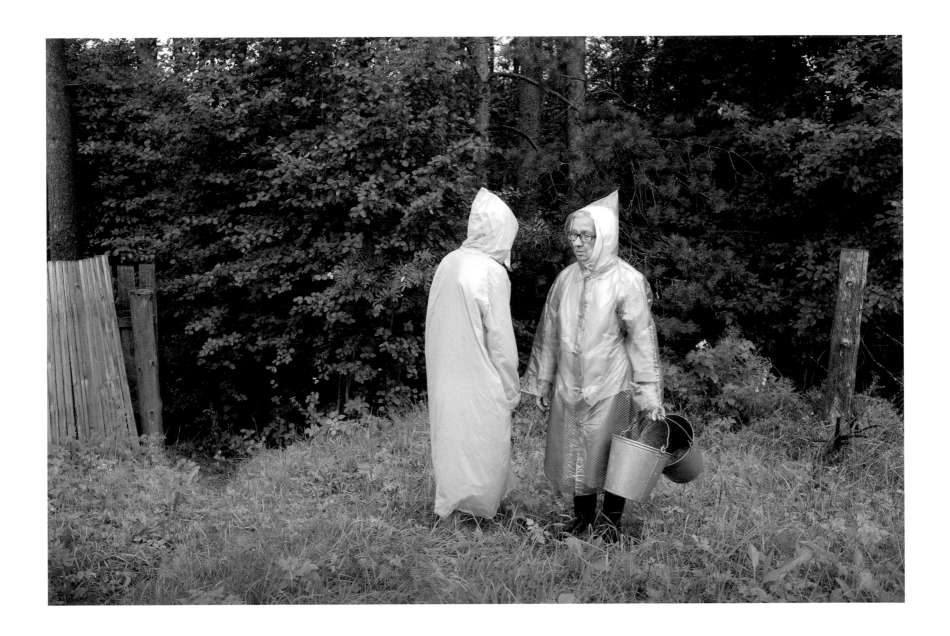

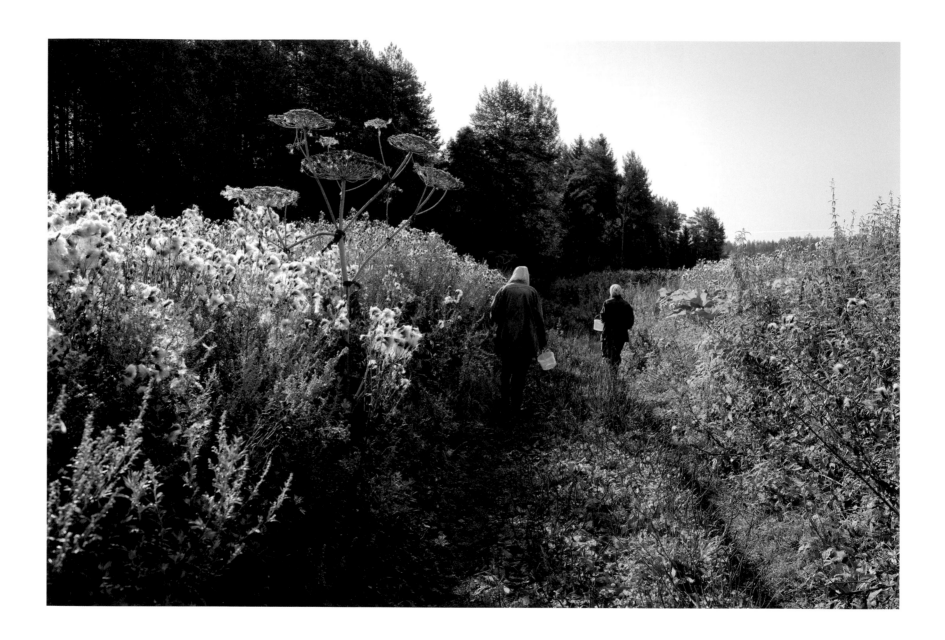

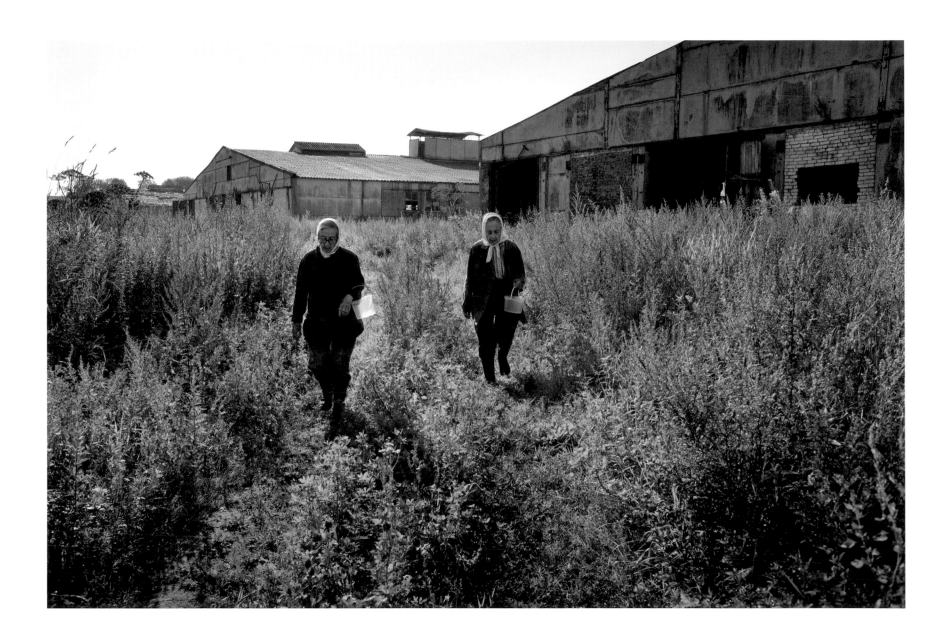

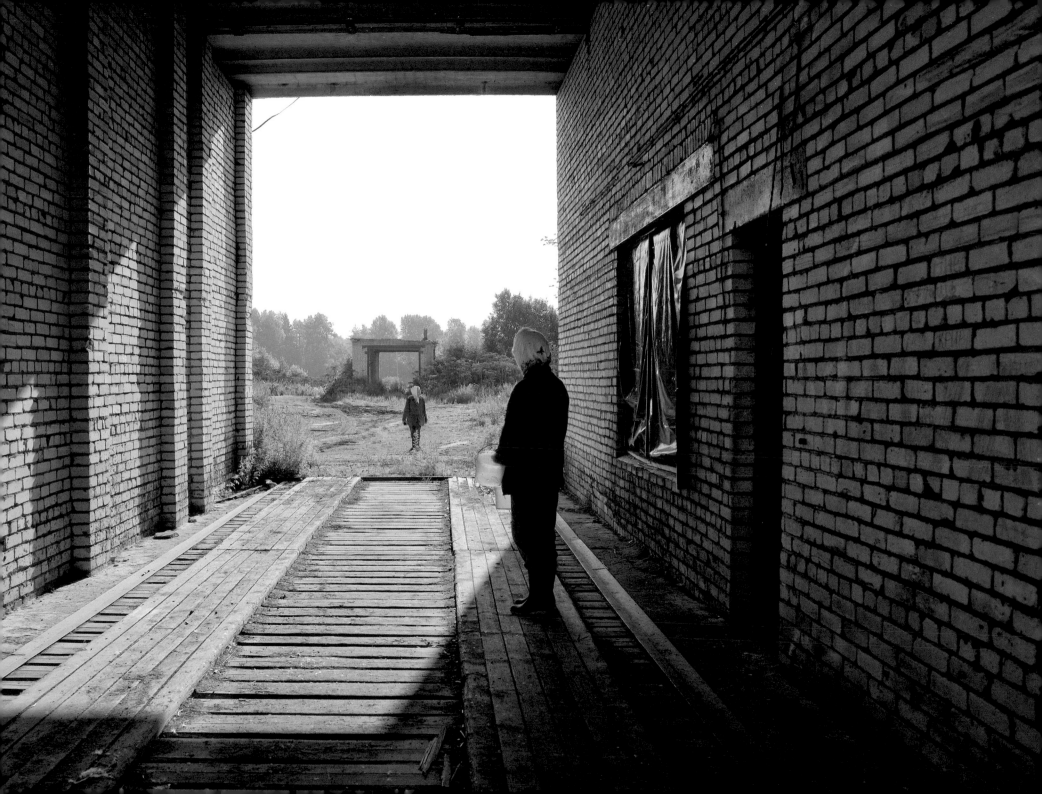

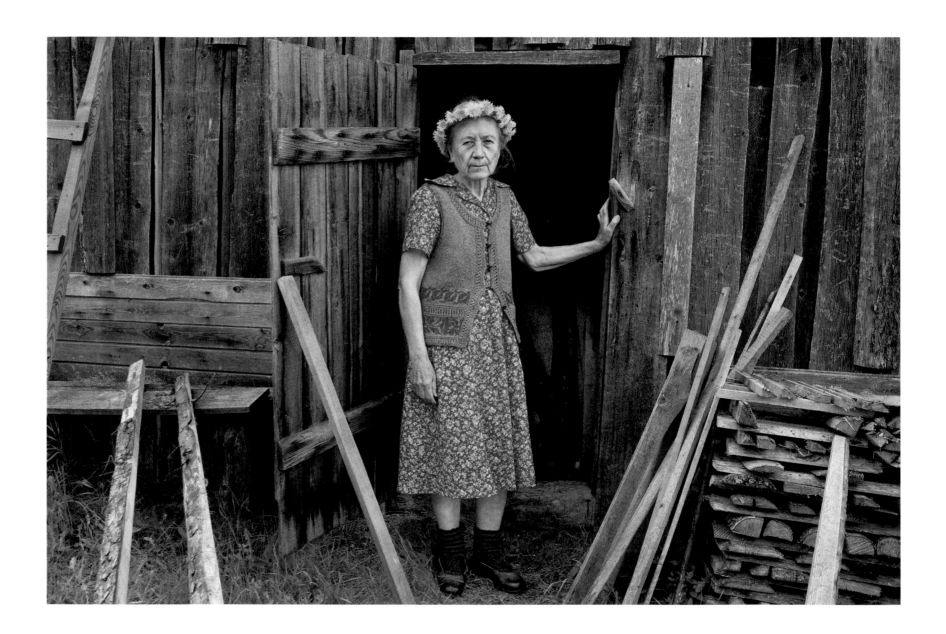

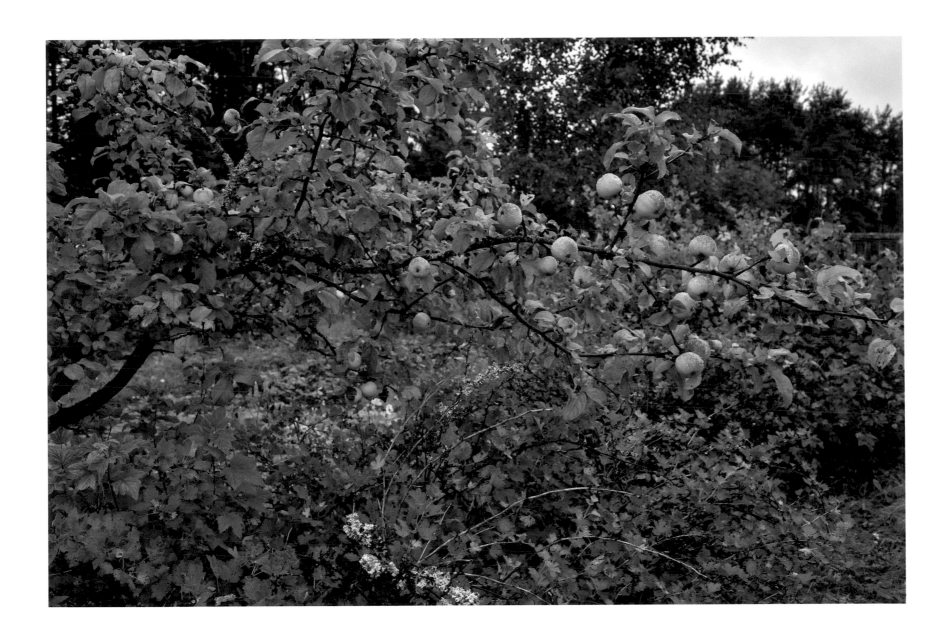

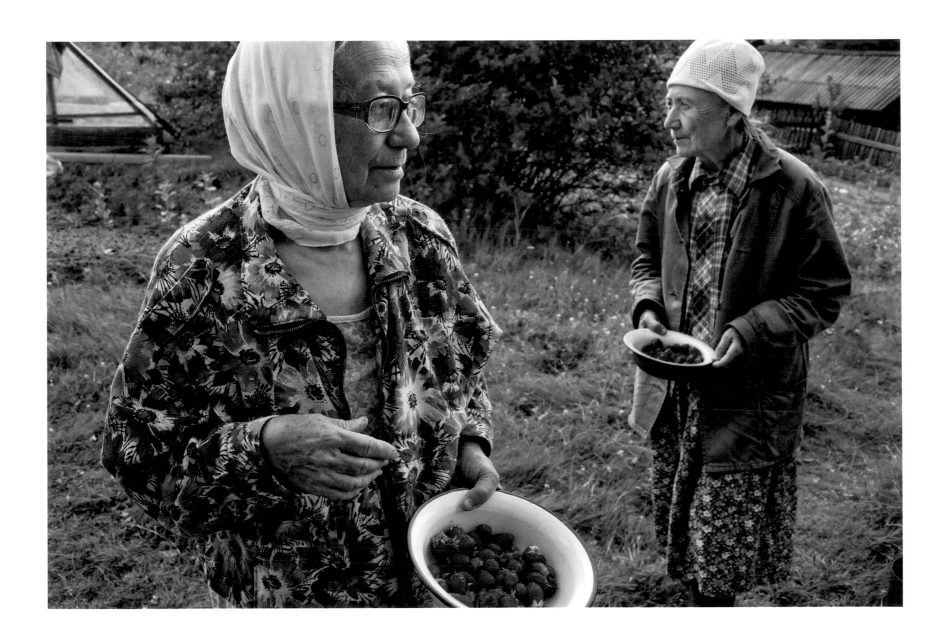

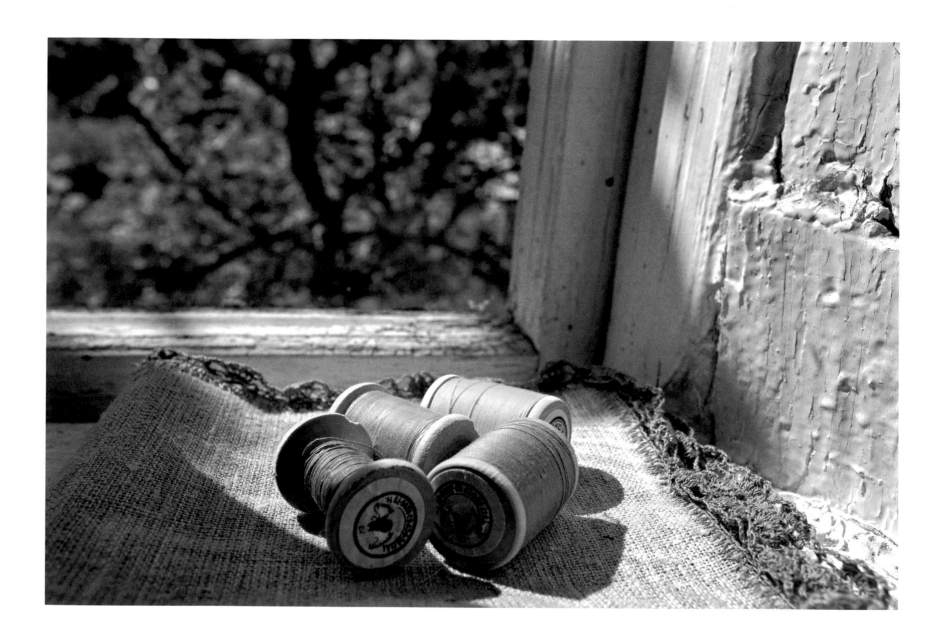

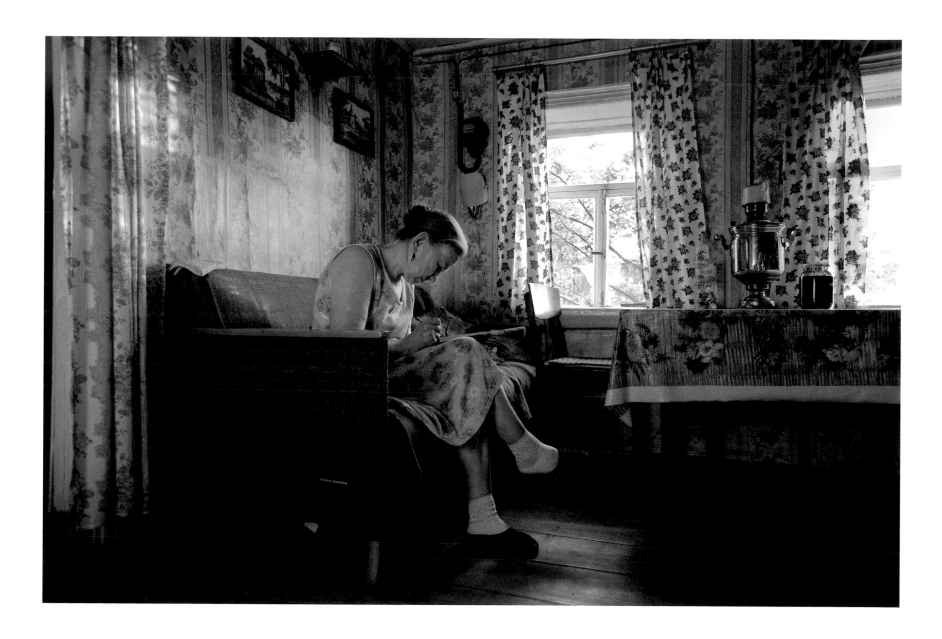

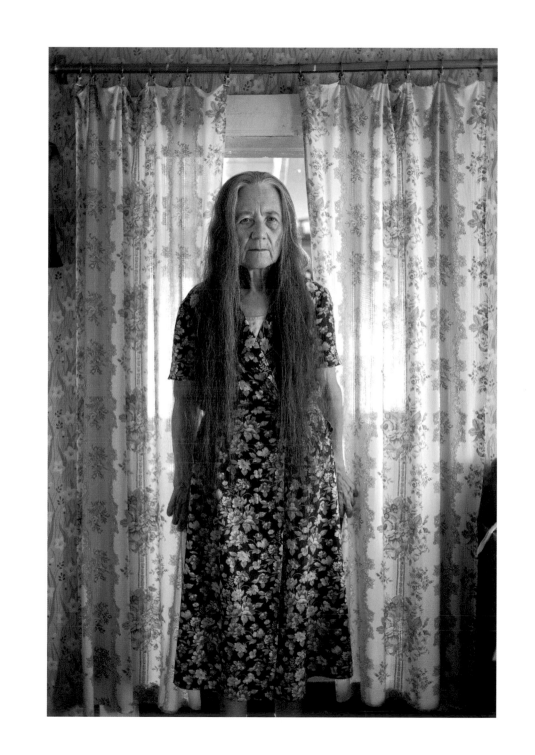

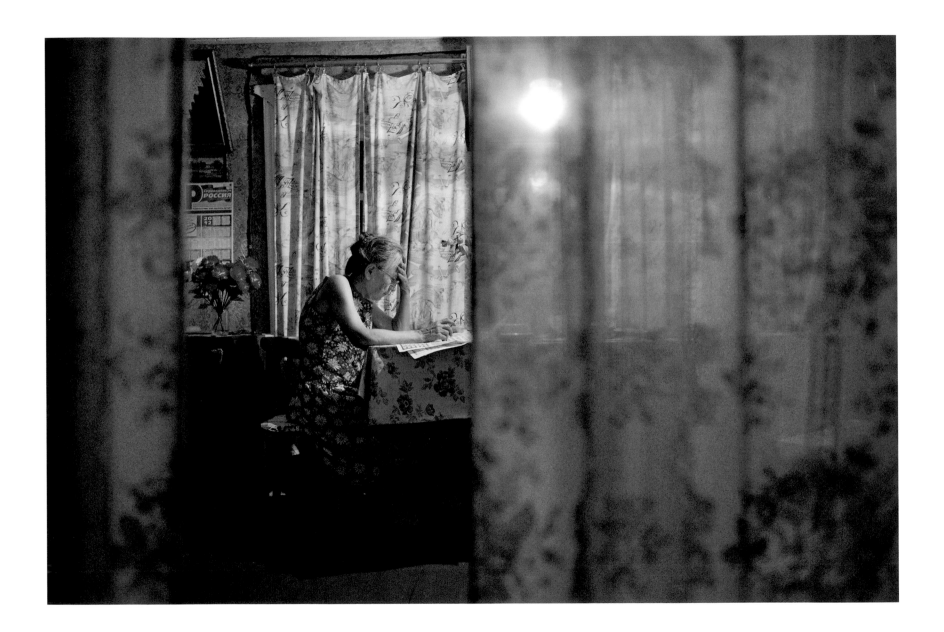

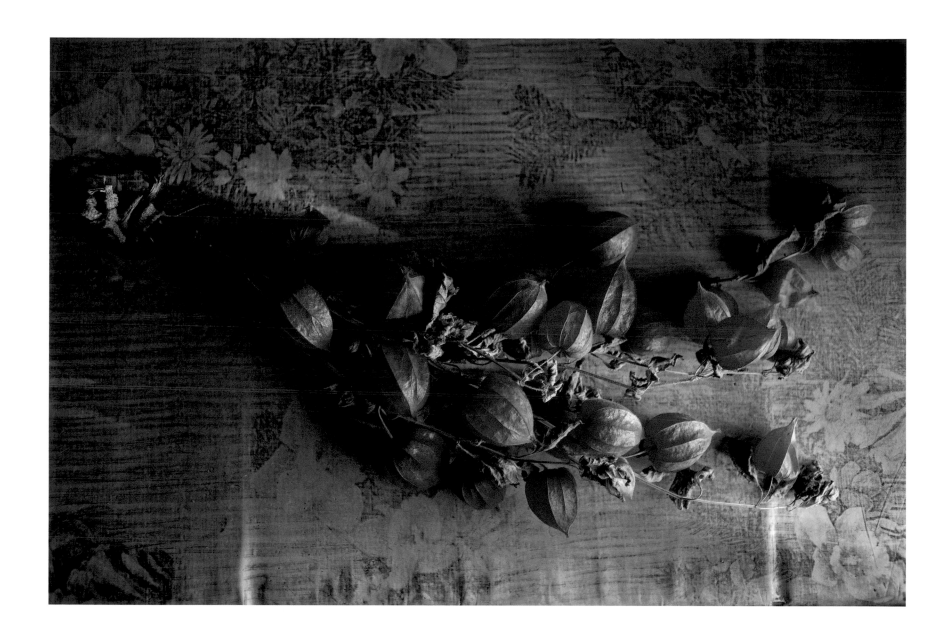

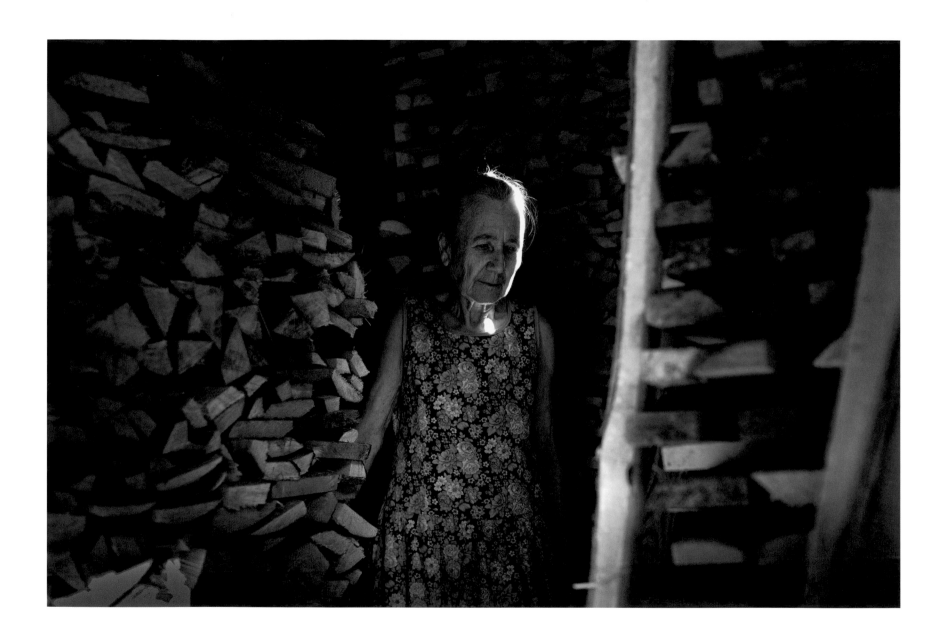

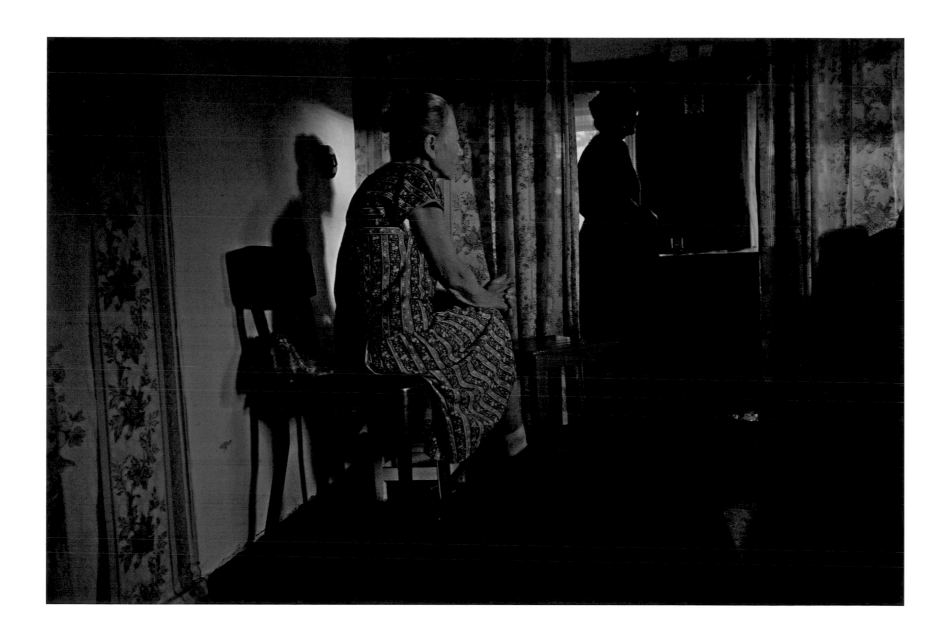

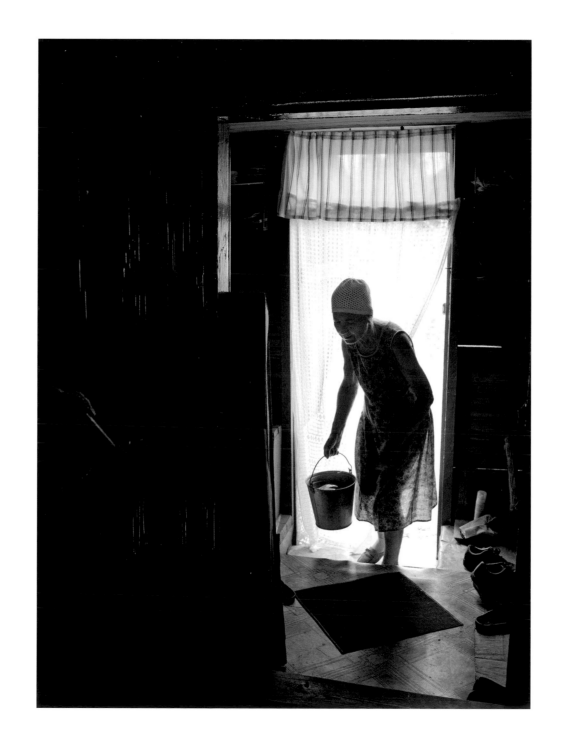

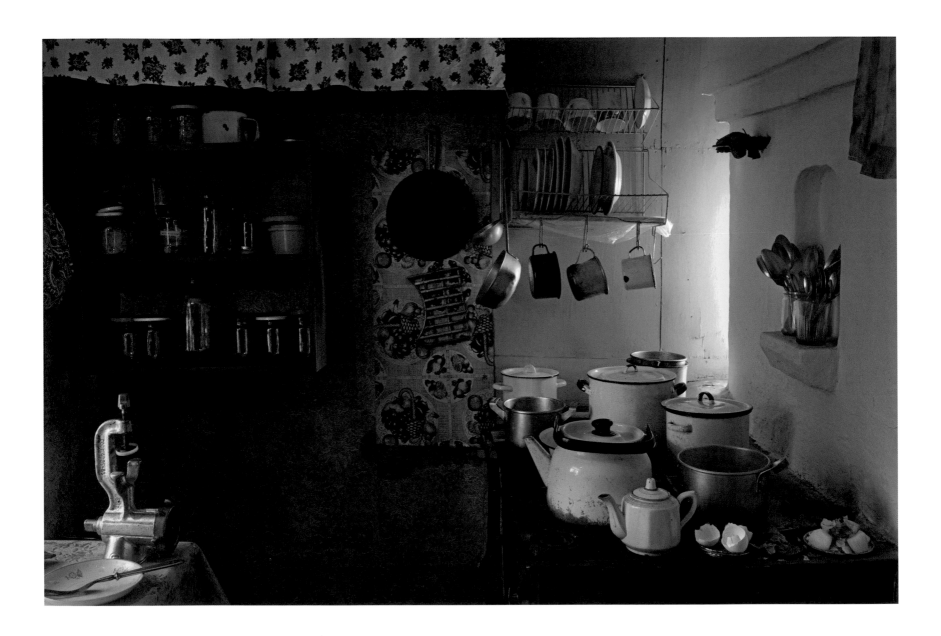

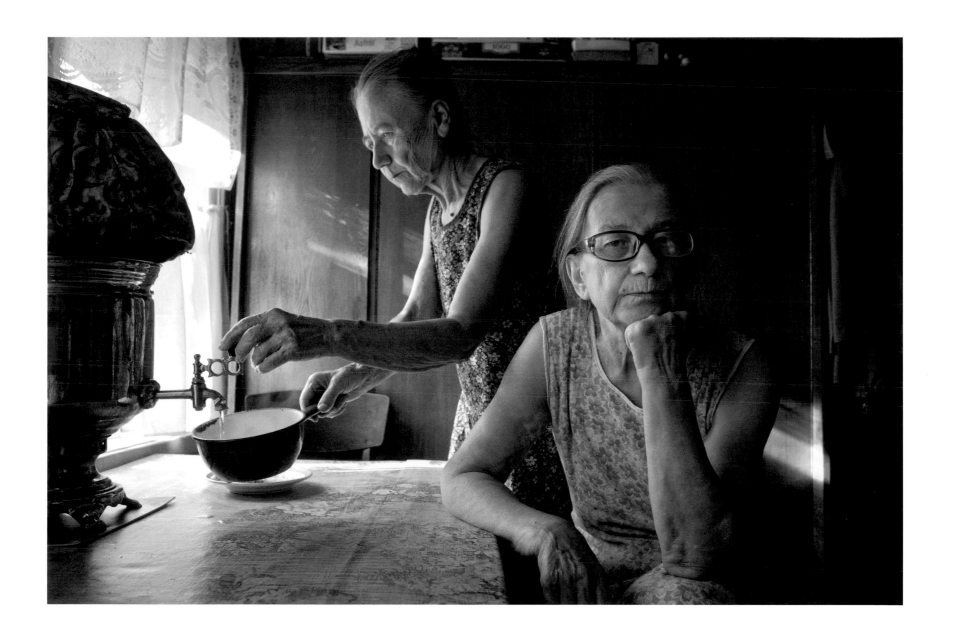

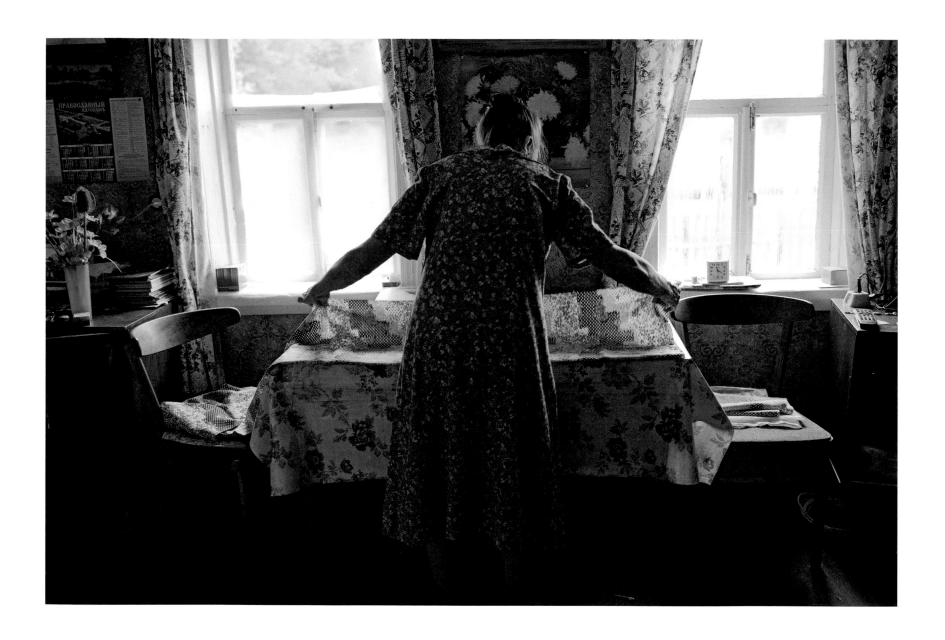

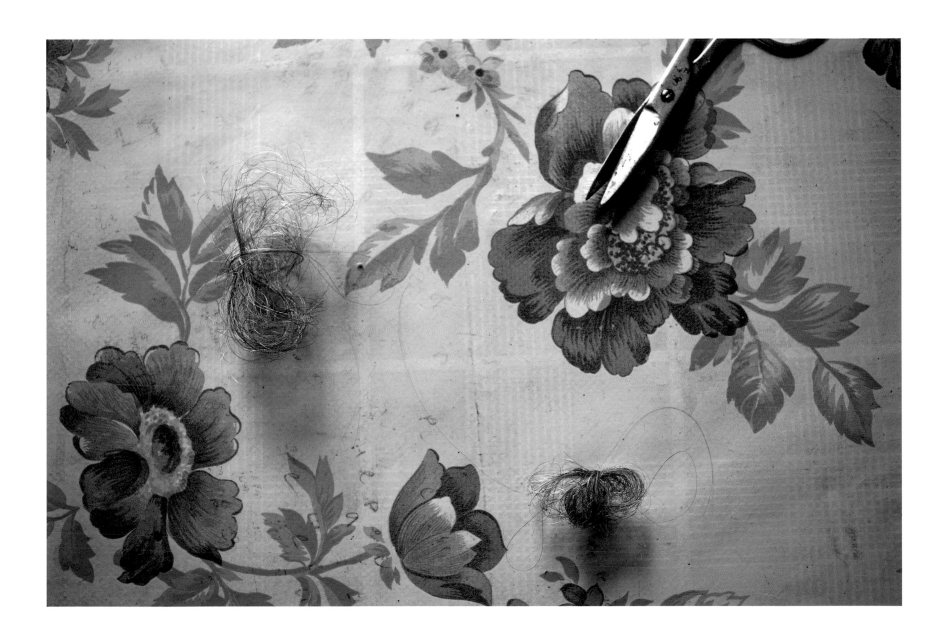

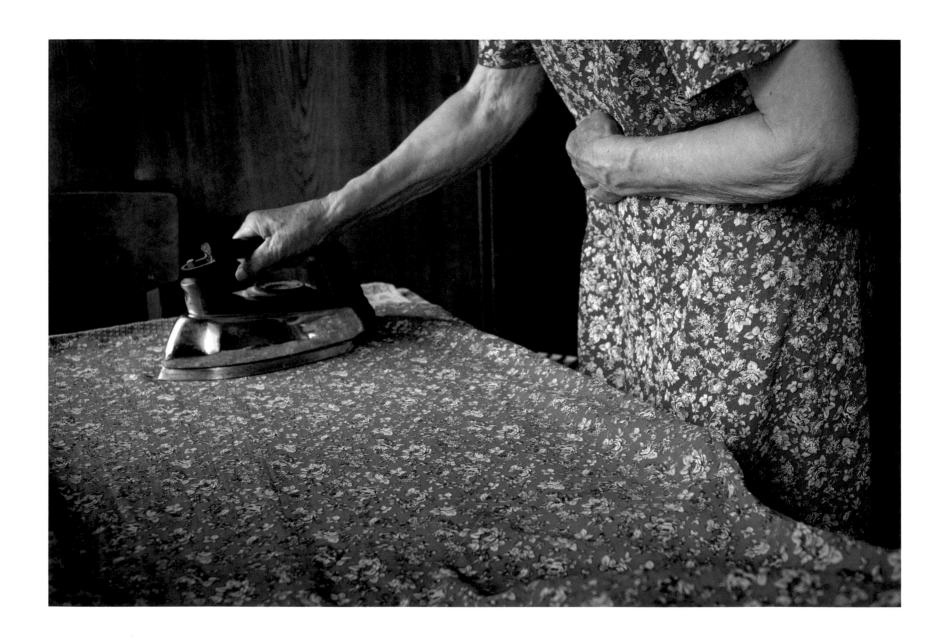

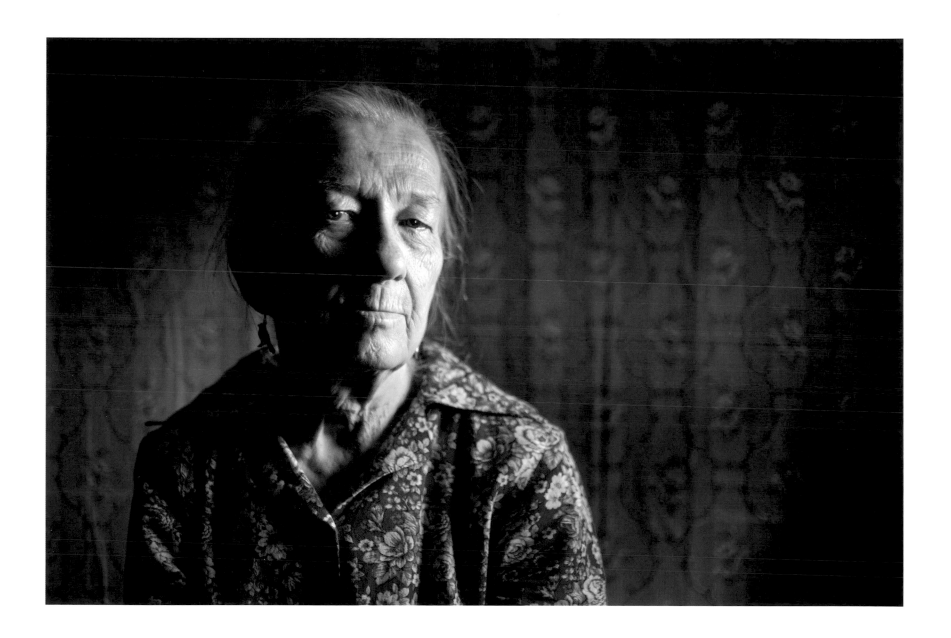

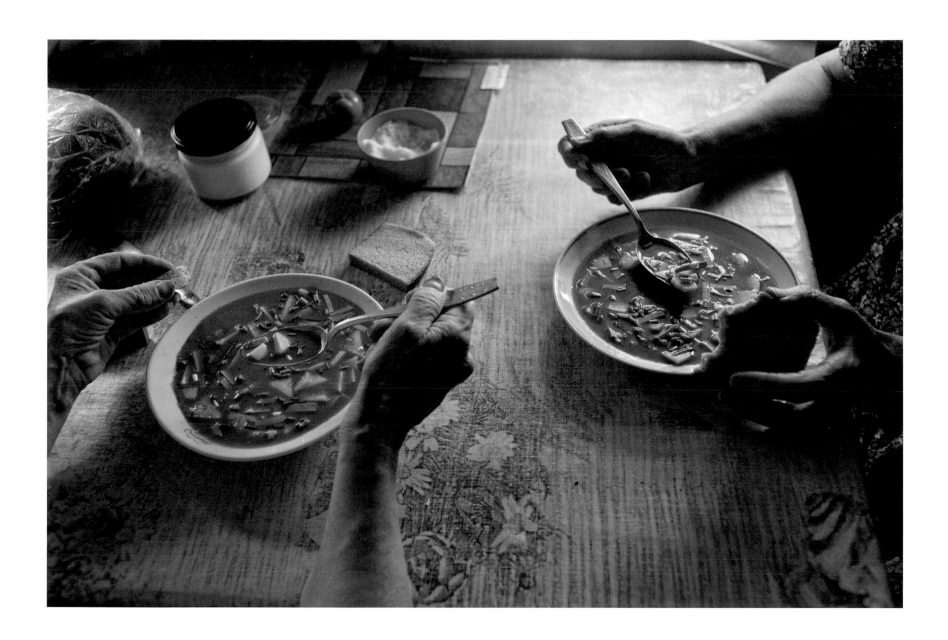

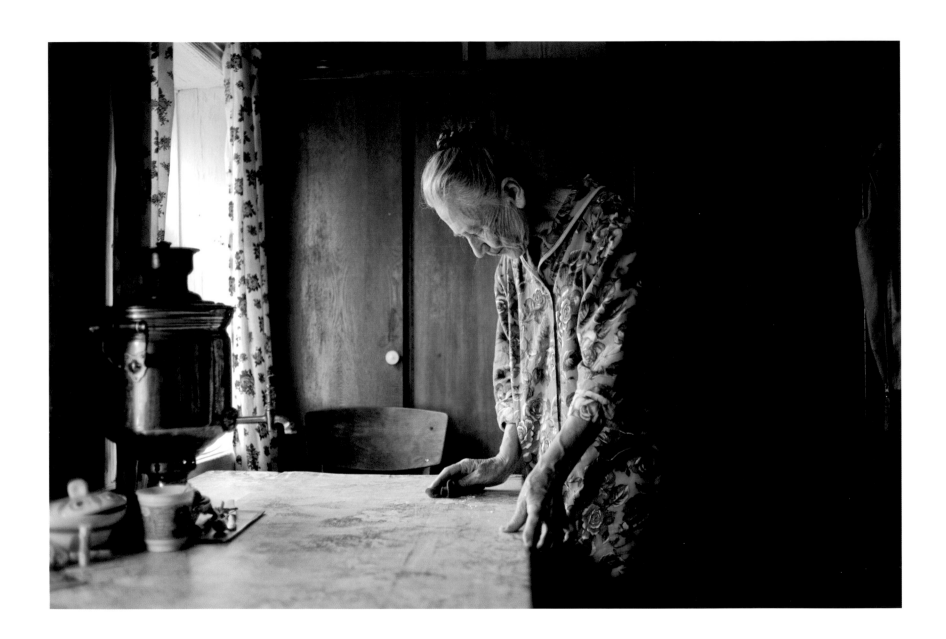

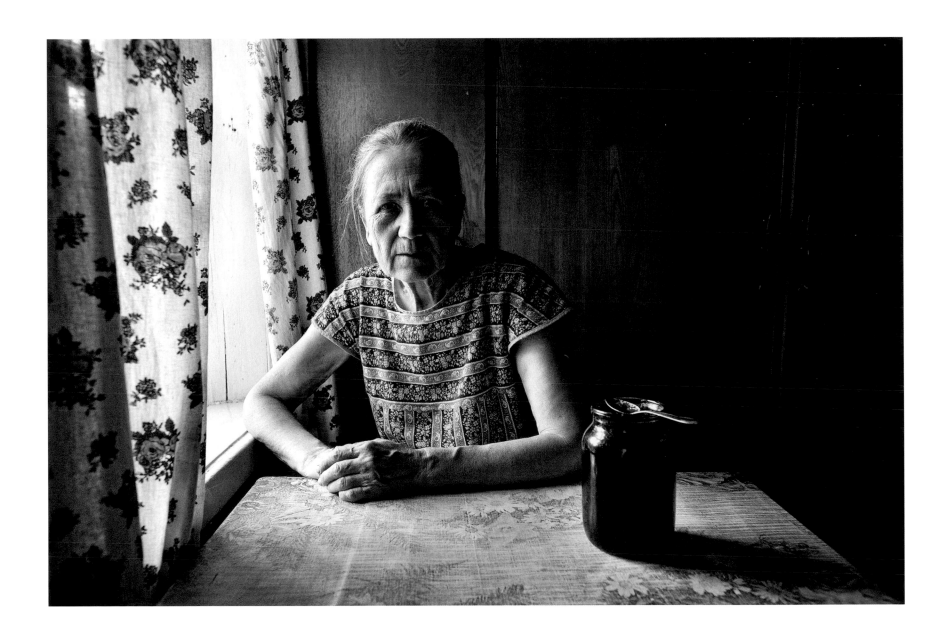

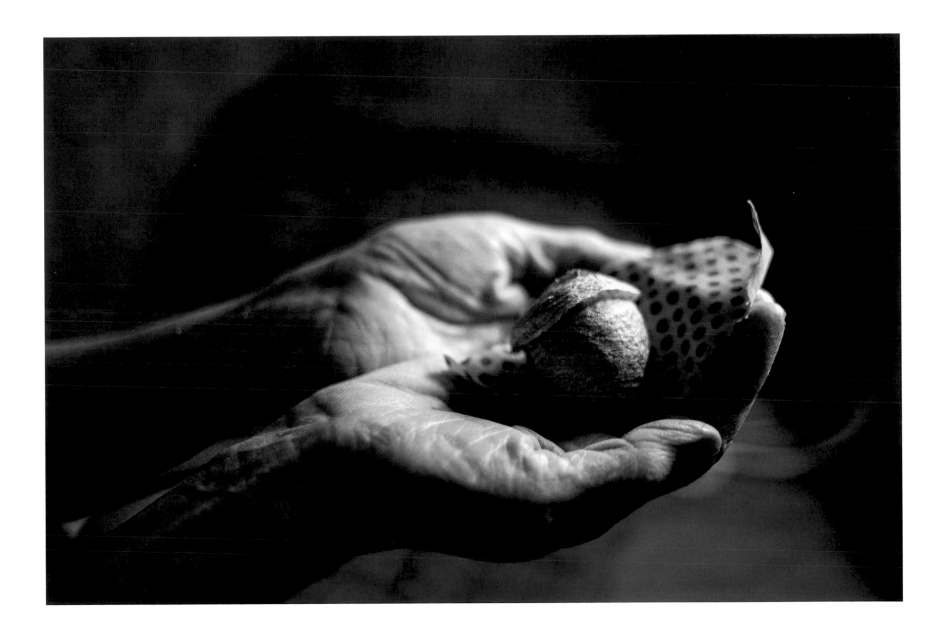

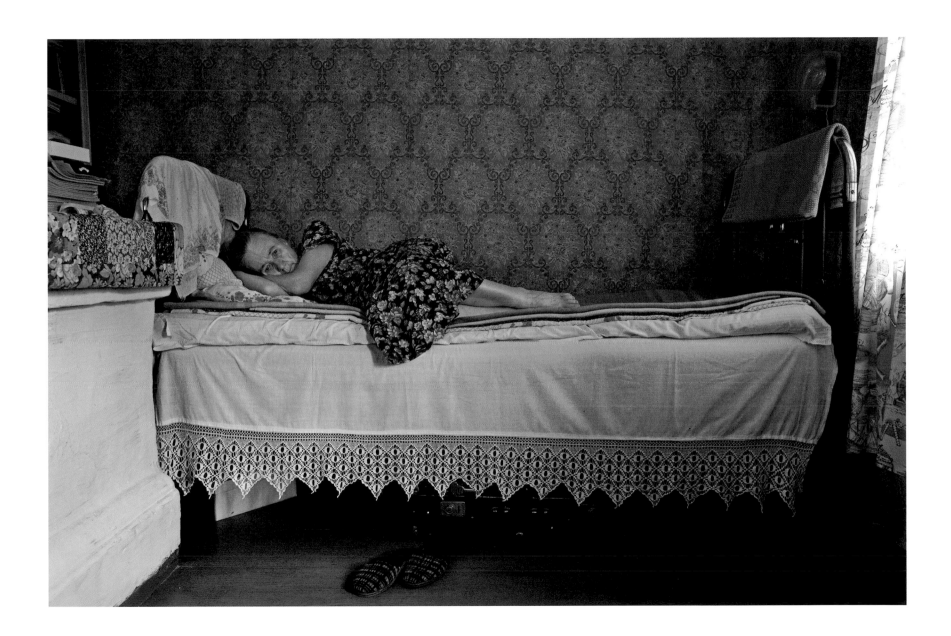

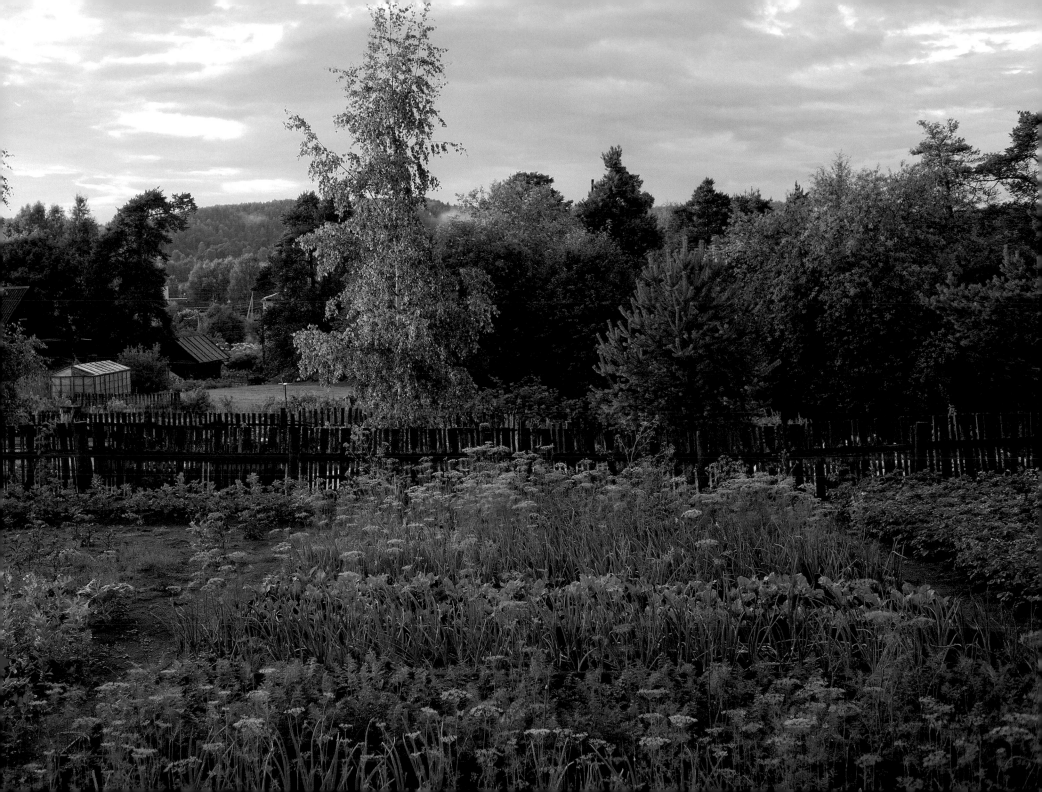

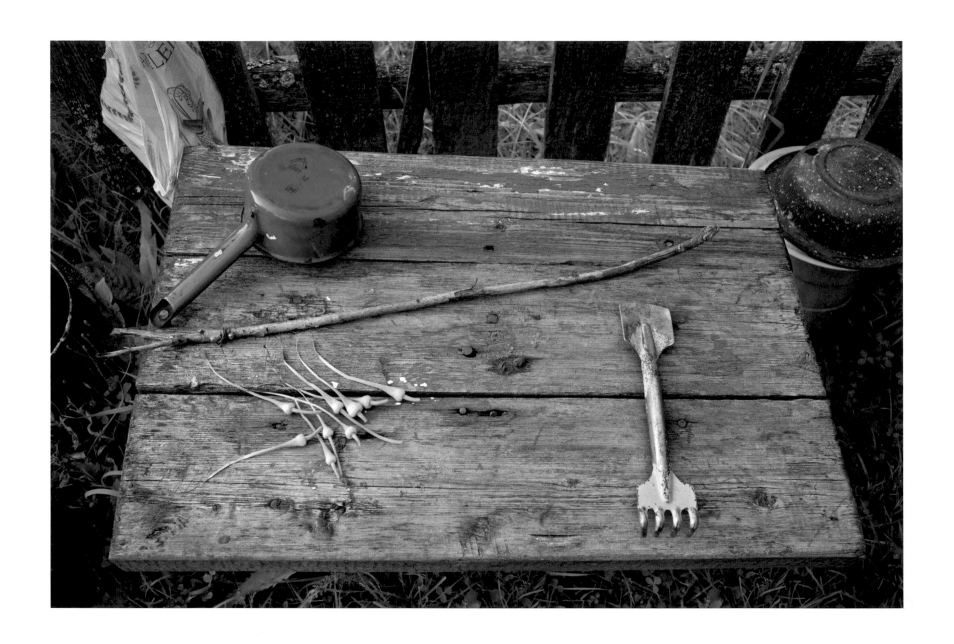

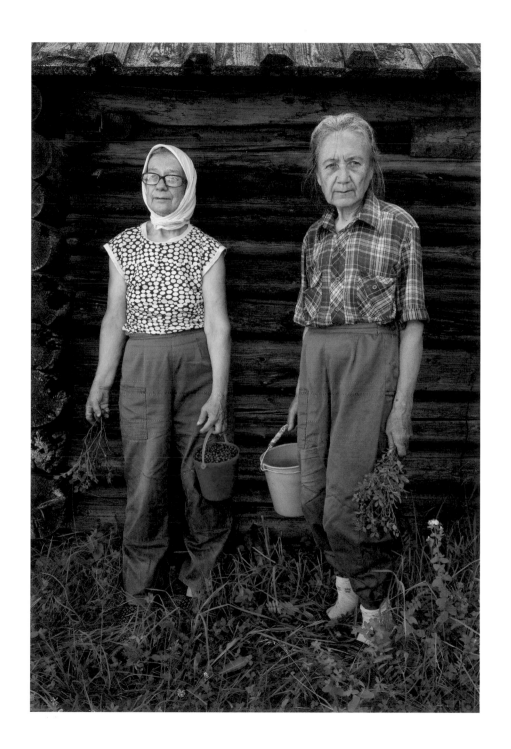

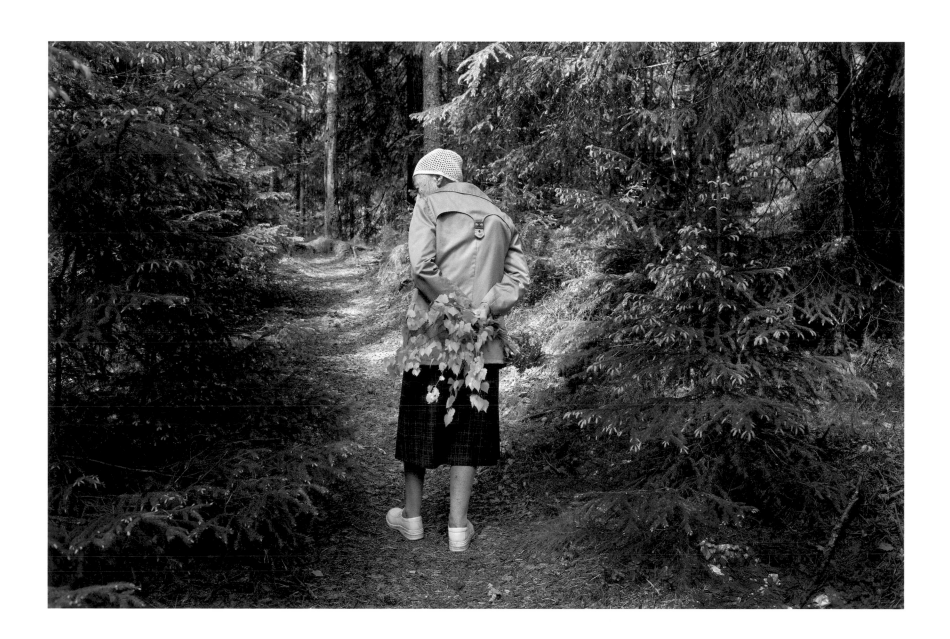

All of the photographs in this book
were taken from 2008 to 2014 in Alekhovshchina,
Leningrad Oblast, Russia, by Nadia Sablin.

AFTERWORD *Nadia Sablin*

In World War II, my grandfather Alexey was a sapper in the Russian Army on the Karelian Front. Fairly early in the war he was wounded, losing sight in one eye, most of his hearing, and the use of one of his hands. Because of these injuries, he was able to return home to his wife and two daughters. My grandparents had three more children after the war, the youngest of whom is my father.

In 1952, Alexey began to lose the vision in his remaining eye. To help the family get along better, he decided to return home to the place where he grew up. He found an unoccupied hill in Alekhovshchina, a village north of Saint Petersburg, close to his brothers, sisters, and cousins. He took his house apart, log by log, a Roman numeral carved onto each one, and floated it down the Oyat River to its present location and reconstructed it. With family close by, my grandfather felt more at ease. When he completely lost his sight, he was unable to be a full-fledged provider. Alexey's children helped him with the only labor he could perform, weaving baskets and rope bags. My grandmother and the two older girls, Alevtina and Ludmila, ran the household and raised the younger three children.

More than sixty years later, the house is still occupied by my aunts from April to September.

The two women, who spent their youth working in big cities and never married, have relied on each other for support and companionship all their lives. I have been spending my summers with them, photographing their habits and occupations and the small world that surrounds them.

Life wasn't easy for my aunts growing up. My grandmother became ill and needed care far too early. After the youngest children went off to college, life in the village became unsustainable. Alevtina, the oldest

daughter, organized a way for her parents to live with her in an industrial town, sharing a small apartment. After work, Alevtina would rush home to cook, clean, entertain, and scold. As she was more accustomed to city life, she took charge of her parents and became the head of the family, which now lived in multiple cities across the Soviet Union. It was Alevtina who continued to hold the family together after her mother died, hosting visitors and organizing summer trips to Alekhovshchina. A passionate young woman, she had determination enough to keep her father alive and healthy well into his eighties, teach him Braille, and facilitate his activism for the blind and deaf community, as well as keep up with music, theater, literature, and her large group of women friends.

Alevtina's siblings and their spouses each used their vacation time in turn to take care of the house, spend time with their father, and introduce their own children to the village. I too spent my summers there, watched by my aunts and uncles, going with them to gather berries in the woods or fish in the river. When I was old enough, I was sent to buy fresh bread in the shop or get milk from the collective cow farm behind the house.

My grandfather, I adored. All day he would sit outside with his portable radio and hearing aid, moving from bench to bench to remain in the sun. I would bring him wild strawberries and beg for fairy tales, long ones with bog devils and languishing princesses.

For me, a city girl, time in the village was both exciting and difficult. As I got older, I was very bored at times, so I began to read, descending from my room only to eat at strictly appointed meal times—tea at 11:30, supper at 7:00—be late and go hungry. That's really where books happened for me, in the attic of my aunts' house, in a small room that my father built when he got married. I'm much more influenced by writers than artists or photographers. Mikhail Bulgakov, Gabriel García Márquez, and Haruki Murakami introduced me to Magical Realism—a world that I was already inhabiting.

A talking cat or a rain of marigolds makes perfect sense to me, because that's how I experience the village—or maybe it becomes true in the village of my photographs. The images, both real and imagined, are part of a process of forgetting and remembering. Life there is never easy, and the hard realities of my aunts' physical labor jar me when I first return. But then my memories and my imagination flood my perceptions, and Alekhovshchina begins to transform back into a magical place all over again.

My parents and I left for the United States in 1992, when I was twelve years old. I was afraid I would never see the house or my grandfather again. In the '90s, the times were turbulent, the future uncertain. Being the first of my father's siblings to retire, Alevtina and Ludmila took on the summer trips to Alekhovshchina in earnest. My father would call them every week to check in. They were very self-sufficient: "We don't need help. We've cut down the pine trees and turned the meadow into a potato field. We have potatoes all year long now." They chopped wood to heat the house, brought water from the well, planted vegetables, made their own clothes. The other aunts and uncles, busy with their families, had less time for the village, and it increasingly fell to the two older sisters to maintain the house, care for their father, and grow food. After my grandfather died, Alevtina insisted that she and Ludmila keep going to the village for the warmer half of the year.

When I was finally able to return, it was as though nothing in the village had changed. The air still smelled of pinecones and the tablecloth on the dinner table was the same one I remembered from childhood. If you climb Bald Mountain (a somewhat aspirational name for the tallest hill in Alekhovshchina), you can see the entire village and a fair part of the road that leads on to Tikhvin Monastery. Most people who travel to the area blow right through the town—there is still no hotel or café to welcome visitors.

My aunts' life is bound to the cyclical nature of things. Alevtina wakes up at 7:00 and gets firewood to heat up the stove for oatmeal. A large kettle of water bubbles on the iron surface: soup and potatoes for lunch. When Ludmila wakes up, my aunts braid and pin up their hair. Breakfast is a quick and quiet affair—it's time to get to work. While the grass is damp with morning dew, there are chores to do around the house. The floors are washed once a week; there are clothes that need mending. If the weather is dry, my aunts head into the garden, where there is always weeding and watering to be done, ants to be eradicated, fences to be repaired, little wooden borders to be built for the vegetable beds. In July, they make jam from currants and gooseberries from the garden.

Eleven-thirty is teatime—a small ceramic cup, a jelly candy cut into tiny pieces, bread with homemade jam. A few facts about the weather are exchanged.

Each sister is in charge of specific duties. Alevtina cooks, goes to the store, gets milk from a cousin, performs most of the manual labor. Ludmila cleans up, weeds, arranges woodpiles in the shed, knows where everything is stored. She is a shy and quiet woman, the one everybody in the family protects. She likes to complain and grumble, but everything she touches becomes beautiful. She's the one who brings flowers into the house or selects the fabric for the sisters' dresses. When she sews or cleans berries her soft, methodical movements are graceful, like a child's.

I have been spending summers with my aunties for seven years now, and it has been a bittersweet experience. They are older and more in need of companionship, and though I found them somewhat alien when I was a child—having never had children, they didn't know how to talk to me—I am now in love with everything about

them. The very anachronisms and quirks that offended my childish sensibilities are now what draw me to them. The first year I was impressed to see Alevtina wield an axe to chop firewood and Ludmila scramble up a huge pile of discarded planks at the sawmill that replaced the collective cow farm. These days there is much less activity and the television takes up more and more of their attention.

The sisters talk very little, exchanging only facts or news. As with my grandfather twenty-five years ago, I ask them for stories. To appease me, Alevtina will sometimes recount tales from her college years—the time she bought an underground banned book, the way her girlfriends played with her hair, draping it on their own heads, the time she asked everyone at her dormitory for a few kopecks so she could buy tickets for a concert, how she once fainted at the movie theater because she was so overcome by feelings.

Ludmila will not tell personal stories, but she knows hundreds of poems and songs by heart and can speak at length on any time period in Russian history, remembering all the different Vladimirs, Igors, and Vladislavs who have gone to war with one another over the centuries. Her sense of fashion is as impeccable as it is unique. If not for her pronounced shyness, I think she could have been a fashion designer. Most women her age have switched to modern textiles, whatever is available at the local shops, but Ludmila has bolts of Soviet cotton stored away in old valises and can pick out an unexpected fabric that surprises with its boldness of color or the simple sweetness of its delicate flowers. Even the basic wool socks and vests that she knits have a twist—a Scandinavian design at the ankle or shiny red buttons as trim.

Now that they are less active, my aunties ask me not to take so many photographs. I spend more time just watching them, my camera put away, and I have started reading in the attic again. The labor of running this small farm and old house has kept the two of them fit and given them an occupation. They have kept close to their family and their land, maintaining customs passed down for many generations. Their life revolves

around the patterns of days and seasons—the preparations, the chores, the satisfactions of self sufficiency. Without Alevtina's determination that they continue to keep up the house in the village, the sisters would most likely be sitting alone in their own apartments in Lodeynoye Pole and Veliky Novgorod, where they spend their winters.

Their strength is ebbing, and they don't like me to see how tired they get performing actions that were once easy. I admire my aunties' fortitude, strength of character, and reliance on each other—for refusing to give up. Leaving the village and returning again divides our time into chapters, as our book moves toward its last pages.

When I took pictures during my first visit, I had an idea to shoot a "little story." But once I started I knew I had to keep going, that I wanted to capture the larger experience of being with them, in the house, in the village. Taking pictures was also a way to reintroduce myself to my aunts—to share what I do.

In the beginning I asked them to pose. To unbraid their hair or rearrange the furniture or do a puzzle—to recreate memories I had from childhood. As time has gone on, I've let them take the lead more and more, often simply recording their actions. We go back and forth, with Alevtina telling me to get up early the next morning to accompany them to the forest or with me asking Ludmila to weave a wreath of dandelions so I can make a portrait of her wearing a crown.

These photographs are interpretations of truth—a retelling of what happens during my aunts' summer days. But they are true to how I experience being in their world, a place both real and enchanted.

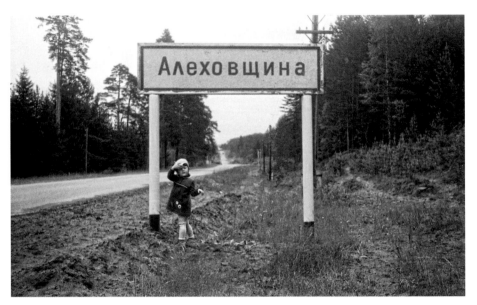

Photograph by Vasiliy Sablin

И самое главное, я благодарна Алевтине
и Людмиле Саблиным. Спасибо, тетя Аля и тетя Люся,
за вашу красоту, за любовь и терпение,
с которым вы помогали мне работать. За то,
что вы открыли мне ваш мир, полный тишины,
солнца и цветов. Эта книга ваша.

ACKNOWLEDGMENTS

First and foremost I want to thank my parents, who have supported me in so many ways throughout my life. I'm grateful to them for sending me into exile in the village every summer when I was young, and for bringing me to America when the future in Russia became uncertain. I thank them for making me believe that following my dreams is paramount and for being there every step of the way.

And Scott Cox, my marvelous partner, whose advice, encouragement, and trust in me have shaped my photography. I'm grateful that he came on adventures with me when he could, and that he made it easy for me to go alone when he couldn't.

I'm incredibly grateful to Alexa Dilworth, my editor at the Center for Documentary Studies at Duke University. Her enthusiastic involvement made each stage of making this book exciting. And to Yolanda Cuomo and Bonnie Briant, whose vision and utter competence have given a whole new dimension to the project. To Nancy Hoagland, Emily Young, Michael McCullough, and all the wonderful staff at Duke University Press, who made this book into something you could hold in your hands. To Sandra Phillips for her understanding of the work, her support, and her wonderful essay. And a special thank you to Lynne Honickman of the Honickman Foundation and Iris Tillman Hill of the Center for Documentary Studies for making the First Book Prize in Photography a reality.

The creation of these photographs over the last seven years was supported in part by the Puffin Foundation, the New York Foundation for the Arts, and the Firecracker Photographic Grant. I'm especially beholden to Sean O'Hagan and Fiona Rogers for being my champions.

Thanks also to my teachers Mark Klett, Betsy Fahlman, James Hajicek, and Carol Panaro-Smith, who were invaluable mentors throughout my grad school years. I am indebted to them for looking at thousands of unedited photographs, and for pushing me to think more deeply about my work while dismissing my self-doubt and angst. And to John Risseeuw and Daniel Mayer for teaching me everything I know about making books from concept to execution.

I will always be grateful to Elizabeth McDade for being the first teacher to be interested in my photographs and for finally making me understand f-stops, and to Gunther Cartwright, whose lecture on the decisive moment blew my mind. I am forever beholden to Dr. Charles Bergengren; his captivating tales in art history class instilled in me a lifelong desire to learn about art and to become a storyteller.

I am grateful to my students for falling in love with photography over and over right before my eyes.

And of course I am profoundly thankful for my aunties. Alevtina and Ludmila are my inspiration.

THE HONICKMAN FOUNDATION

The Honickman Foundation is dedicated to the support of projects that promote the arts, education, health, and social change. Embodied in this commitment is a fundamental belief that creativity enriches contemporary society, because the arts are powerful tools for enlightenment, equity, and empowerment: Hence, this focus to help expand, nourish, and center attention on contemporary photography. It is the Foundation's aim to stimulate America's energetic photo-collecting universe into the full realization of photography's rich accomplishment and potential, both as an art form and as a tool for social change.

THE CENTER FOR DOCUMENTARY STUDIES/
HONICKMAN FIRST BOOK PRIZE IN PHOTOGRAPHY

This biennial prize offers publication of a book of photography, a $3,000 award, and a solo exhibition. Each year a significant and innovative artist, curator, or writer in photography is chosen to judge the prize and write a foreword to the winning book. The prize is open to North American photographers who use their cameras for creative exploration, whether it be of places, people, or communities; of the natural or social world; of beauty at large or the lack of it; of objective or subjective realities. The prize honors work that is visually compelling, that bears witness, and that has integrity of purpose.

Acclaimed photographer Robert Adams, the prize's inaugural judge, selected Kansas-based photographer Larry Schwarm to win the first prize competition in 2002 for *On Fire,* because his series of color images of fire "are so compelling that I cannot imagine any later photographer trying to do better."

Maria Morris Hambourg, founding curator of the Metropolitan Museum of Art's Department of Photographs, picked Steven B. Smith to win the second competition in 2004 for *The Weather and a Place to Live,* his black-and-white photographs of the surreal intersection of suburbia and desert in California, Utah, Nevada, and Colorado—"elegant, delicately nuanced pictures that are pitch perfect."

Robert Frank, one of America's most influential photographers, judged the third biennial competition in 2006 and chose Danny Wilcox Frazier to win the prize for *Driftless: Photographs from Iowa,* because of his "passionate photographs without sentimentality. . . . His work reaches out: let me tell your story, it is important."

Celebrated photographer Mary Ellen Mark judged the fourth competition in 2008 and selected Jennette Williams as the winner for *The Bathers,* her platinum palladium photographs of women in Hungarian and Turkish bath houses that "speak powerfully about women's own private sense of identity and beauty."

William Eggleston, whose groundbreaking reinvention of color photography established him as one of America's most original artists, selected Benjamin Lowy to win the fifth competition in 2010 for his arresting color photographs, *Iraq | Perspectives,* taken through Humvee windows and night vision goggles over a six-year period.

Renowned curator, historian, and photographer Deborah Willis chose Gerard H. Gaskin as the winner of the sixth biennial competition in 2012 for *Legendary,* color and black-and-white photographs of the house ballroom scene in New York and other cities—"In search for beauty, Gaskin's photographs open our eyes to an extraordinary community of artists who are *performing* beauty."

Aunties: The Seven Summers of Alevtina and Ludmila
Photographs and text © 2015 by Nadia Sablin
Foreword © 2015 by Sandra S. Phillips

BOOK DESIGN BY YOLANDA CUOMO, NYC
Associate designer: Bonnie Briant
Printed in the United States of America

Cover: *The last strawberries, Alekhovshchina, Leningrad Oblast, 2009*

Sablin, Nadia, 1980– photographer.
Aunties : the seven summers of Alevtina and Ludmila / photographs by Nadia Sablin ; with a foreword by Sandra S. Phillips.
pages cm
"Selected by Sandra S. Phillips to win the Center for Documentary Studies/
Honickman First Book Prize in Photography." Includes bibliographical references and index.
ISBN 978-0-8223-6047-6 (hardcover : alk. paper)
1. Russia, Northwestern—Social life and customs—Pictorial works.
2. Documentary photography—Russia, Northwestern.
3. Photography—Awards—United States.
I. Phillips, Sandra S., 1945– author of foreword. II. Title.
TR820.5.S23 2015
770.947—dc23
2015019165

Duke University Press
www.dukeupress.edu

CDS Books, published by the Center for Documentary Studies, are works of creative exploration by
writers and photographers who convey new ways of seeing and understanding human
experience in all its diversity—books that tell stories, challenge our assumptions, awaken our
social conscience, and connect life, learning, and art.

Center for Documentary Studies at Duke University
documentarystudies.duke.edu

First printing